Liverpool Hidden Walks

Claire E. Rider &
Neil McDonald

Published by Geographers'
A-Z Map Company Limited
An imprint of HarperCollins Publishers
Westerhill Road
Bishopbriggs
Glasgow
G64 2QT

HarperCollinsPublishers
Macken House, 39/40 Mayor Street Upper,
Dublin 1, D01 C9W8, Ireland

www.az.co.uk
a-z.maps@harpercollins.co.uk

1st edition 2023

A catalogue record for this book
is available from the British Library.

ISBN 978-0-00-856496-4

10 9 8 7 6 5 4 3 2 1

Printed in India

MIX
Paper | Supporting
responsible forestry
FSC™ C007454

This book is produced from independently certified FSC™ paper
to ensure responsible forest management.

For more information visit: www.harpercollins.co.uk/green

contents

introduction

Liverpool, both visually and economically, has benefited from being on the River Mersey, a direct sea route to the world. Once the second port of the British Empire, the city built the world's first wet dock in 1715 and capitalized on the slave trade. Ships imported sugar, cotton, rum, tobacco, to be stored and sold. Nearly 200 years of direct economic liquidity from slavery financed the city, with another eighty years of growth and consolidation cementing its institutions. Ships, docks and international commerce are still important, though many brick warehouses have been converted and this re-purposing continues.

The constant flow of the Irish settler (and emigrant) helped establish the unique sense of humour and accent. Scandinavian sailors shared their meat and potato stew, 'scouse'; 'Scousers' is slang for Liverpudlians.

There are monumental must-see buildings: St George's Hall, the Catholic and Anglican Cathedrals, the Royal Albert and Wapping Docks, Tobacco Warehouse and the 'Three Graces' on the waterfront. And must-dos include the 'Ferry across the Mersey', St Johns Beacon and the city's museums and green spaces.

Visitors come for the Beatles, football and sporting heritage, and discover that Liverpool has quality and depth to its public realm, from Georgian streets to historic quaysides, Victorian art galleries, libraries and museums. The music and vibrancy of the city are infectious and alluring.

Liverpool's wealth of history and culture are explored in this book to provide you with an insight into one of the world's great cities.

about the authors

Claire E. Rider made the bright lights of Liverpool her home. With a career in further education, tourism and marketing, she relished her role as marketing manager at National Museums Liverpool, promoting art and artefacts, creating events and masterminding festivals. A born-and-bred Scouser, Neil McDonald was a phone engineer for British Telecom, connecting housing estates across the city, and rose to the heights of Head of Customer Service for BT in London.

He left and became a Resort Manager in France.

Claire and Neil both re-trained as Blue Badge Tourist Guides, delighting guests with their knowledge and lively personalities. Together they established and ran Brilliant Tours and Beatleswalk very successfully for seven years. Claire plans to return to education but they both enjoy being freelance tourist driver guides in Liverpool and across the UK.

how to use this book

Each of the 20 walks in this guide is set out in a similar way. They are all introduced with a brief description, including notes on things you will encounter on your walk, and a photograph of a place of interest you might pass along the way.

On the first page of each walk there is a panel of information outlining the distance of the walk, a guide to the walking time, and a brief description of the path conditions

or the terrain you will encounter. A suggested starting point along with the nearest postcode is shown, although postcodes can cover a large area therefore this is just a rough guide.

The major part of each section is taken up with route maps and detailed point-to-point directions for the walk. The route instructions are prefixed by a number in a circle, and the corresponding location is shown on the map.

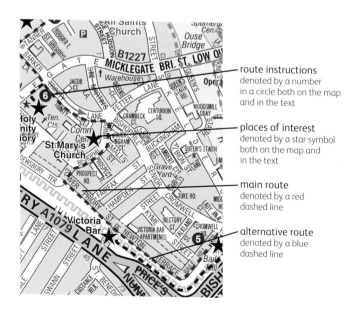

route instructions
denoted by a number in a circle both on the map and in the text

places of interest
denoted by a star symbol both on the map and in the text

main route
denoted by a red dashed line

alternative route
denoted by a blue dashed line

A̅Z̲ walk one

Seven Streets

The original streets of medieval Liverpool.

Although no early buildings remain, the H-shaped layout of the city's first seven streets are explored on this walk, revealing over 800 years of history since the year 1207, when King John issued a Royal Charter to form the borough of Lyrpul. This circular walk through the seven streets starts at James Street Station and takes us through the former commercial district.

Liverpool was once the second port of the British Empire and the wealth accumulated during this time is reflected in the quality of its architecture, with clues literally written on the stone carvings and reliefs of the buildings. This route is packed with hidden gems so extra time has been allowed for looking at the buildings as there are interesting details everywhere, especially along Castle Street and in the Exchange Flags area. Look above doorways or at the highest apexes as there are dates on guttering and elaborate carved stones. Many buildings have now been repurposed as hotels, and along Castle Street there are street cafés and pedestrian walkways that give it a mainland European feel.

The original seven streets were: Dale Street, Castle Street, Chapel Street, Moor Street (now Tithebarn Street), Bancke Street (now Water Street), Peppard or Mill Street (Old Hall Street) and Juggler Street (High Street). Along the way, you will also pass secret bunkers, the world's first skyscraper and a Superlambanana!

start / finish	James Street Railway Station, James Street
nearest postcode	L2 7PQ
distance	2 miles / 3 km
time	1½ hours
terrain	Paved roads and walkways, steps.

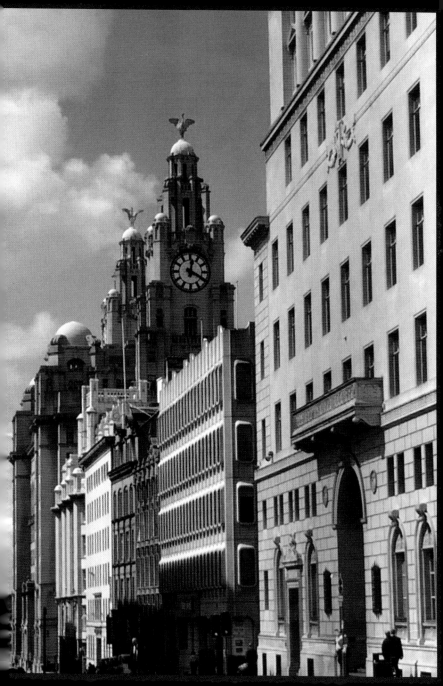

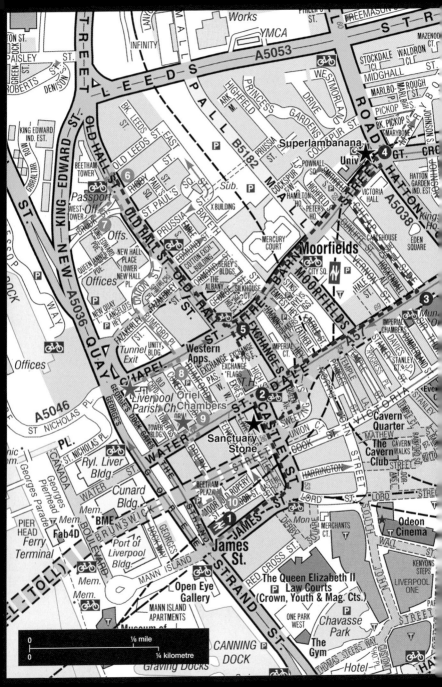

1 Leave James Street Station and walk up James Street, noting the large former bank buildings on the left, until you reach Derby Square. The monument to Queen Victoria was unveiled in 1906 on the former site of Liverpool Castle. The stone from the castle was later used to construct the docks. Turn left and walk along Castle Street, taking time to study each building. Look out for the former Adelphi Bank on the left, with its Russian dome and bronze doors. Pass the former Bank of England on the right and then, set into the pavement on your left, is the 13th-century Sanctuary Stone ★. This stone is said to be the only surviving surface monument of the city's medieval past. On the right there is a beautiful mosaic relief on the British and Foreign Marine Insurance Company Building.

2 Facing you at the end of Castle Street is Liverpool Town Hall, which was built in 1754 and is one of the grandest civic suites in the country. Turn round to head back along Castle Street and take the left turn, walking through Queen Avenue on to Dale Street. Stop and look back at the Queen Insurance Buildings. Cross over Dale Street, turn right and pass Hackins Hey and Leather Lane on your left. These narrow streets contain Liverpool's oldest pubs, such as Ye Hole in Ye Wall. Across the road you'll see a former insurance building, built in 1903, with a gilded dome top and a sundial on the side. Further along Dale Street is another hotel, the former Municipal Building built in 1886 with its splendid clock and spire.

3 When you reach Cheapside turn left, passing the former police cells built in 1859, and continue to Tithebarn Street. On this corner there used to be a Tithe Barn built by Lord Molyneux in 1524 to store the collected tithes, a tenth of a farmer's produce. Turn right and then cross at the traffic lights to see the large, yellow statue with the head of a sheep and the tail of a banana – the Superlambanana, commissioned in 1998 as part of Britain's Art Transpennine exhibition.

4 Turn back down Tithebarn Street, passing Shenanigans pub, an 1841 alehouse previously called the Revolving Lamp. Cross back over Tithebarn Street at the traffic lights just before Old Hall Street.

5 Take the covered walkway into Exchange Flags. In the middle is Liverpool's oldest public monument, which has stood proudly facing High Street since 1815. Nelson is holding up his sword supporting four crowns representing the battles he fought at Cape St Vincent, the Nile, Copenhagen and Trafalgar. Underneath his cloak, a skeleton, the figurative representation of death, is reaching to take his heart. On wall of the Art Deco Martins Bank Building there are reliefs of Neptune with a beard of coins. Leave Exchange Flags the way you entered and walk up another of the original seven streets, Old Hall Street which in the late 1700s was the most aristocratic part of the town, with windmills and potteries dotted along its eastern slope.

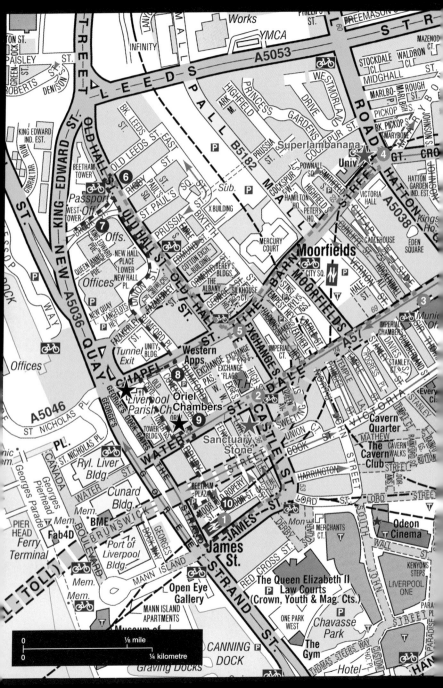

6 At the junction with Old Leeds Street is another Art Deco building, Lancaster House, built in 1936 as the Telephone Exchange. Cross over Old Hall Street to the Radisson Blu hotel opposite. It was on this site in 1236, during the reign of King Henry III, that Sir John de la More occupied a dwelling 'pleasantly sloping down to the banks of the Mersey and commanding beautiful views … to the Welsh hills beyond'. This building was known as the Old Hall. The Grade II listed red brick building next to the hotel was once the coal merchant's office, part of Clarke's Basin, the former terminus of the Leeds & Liverpool Canal until the basin closed in 1886. Turn back down Old Hall Street and turn right onto Brook Street to find Liverpool's tallest building, the 450-foot (137-metre) high Beetham West Tower.

7 Turn right, back onto Old Hall Street, then right into Union Street. Number 7 dates to 1760. Continue into Rumford Place, where wall plaques explain the role of Liverpool in the American Civil War. Cross Chapel Street and look ahead to see flags flying outside the Western Approaches HQ, a secret Second World War underground bunker, now a museum.

8 Turn right along Chapel Street towards the river, passing the remains of a wall bombed in the May 1941 Blitz and an old pub called the Pig & Whistle before you reach Liverpool Parish Church, Our Lady of St Nicholas ★. There has been a place of worship here since 1257,

when the banks of the River Mersey reached the chapel of St Mary's del Quay. The current church was rebuilt in 1815. Walk across the churchyard and through Tower Gardens, then turn left onto Water Street, another of the original seven streets. Oriel Chambers, on the left just before Covent Garden, was designed by Peter Ellis in 1864 and was the first ever building with a curtain-walled design, now the standard for skyscrapers across the world.

9 Cross over Water Street to India Buildings, designed by Herbert J. Rowse in 1932. The building was damaged in the Blitz and reconstructed. Within the entrance is Liverpool's only remaining complete arcade, an ornate walkway once with upmarket shops and a Post Office. Walk back down Water Street then turn left into Drury Lane and cross over Brunswick Street to see the kinetic Piazza 'Bucket' Fountain.

10 Walk across Beetham Plaza to the elevated viewpoint overlooking Liverpool's principal waterfront buildings, the 'Three Graces', right to left: Royal Liver Building (1911), the Cunard Building (1917) and the Port of Liverpool Building (1907). Descend the steps to the left and continue along The Strand, then turn left into James Street. Albion House on the corner was built in 1898 for the White Star Line shipping company, who registered the *Titanic* in this office. Continue up James Street to return to the start.

▲Z walk two

The Mersey Beat

From the Cavern Club to the waterfront.

Two of the things for which Liverpool is most famous are woven together in this circular walk that takes you on a tour of sites and statues relating to the 1960s 'Merseybeat' era, when the city rocked to the music of the Beatles and other artists with a sound that was exported across the world. Starting at the Cavern Club, the walk is set against a backdrop of impressive architecture, which is testament to Liverpool's former status as one of the world's richest ports.

With more listed buildings than any other UK city outside London, you will be rewarded if you look up to examine the detail of the buildings as you walk by. You will pass the 18th-century Town Hall as you walk down to the River Mersey, the lifeblood of the city, and have the opportunity to take selfies at the Beatles statue standing proudly in front of Liverpool's magnificent waterfront buildings.

Royal Albert Dock with its sheltered waters is a photographer's dream, with stunning reflections of wrought iron columns along the colonnades buzzing with shops, museums and eateries. The final part of the walk crosses the UK's largest open-air shopping centre, Liverpool One. This £1 billion development has rebuilt an area that was devastated by bombs during the 1941 Blitz.

start / finish	The Cavern Club, Mathew Street
nearest postcode	L2 6RE
distance	1¾ miles / 3 km
time	1 hour 30 minutes (excluding museum visit)
terrain	Paved roads and paths, with some uneven pavements in the docks. One set of steps.

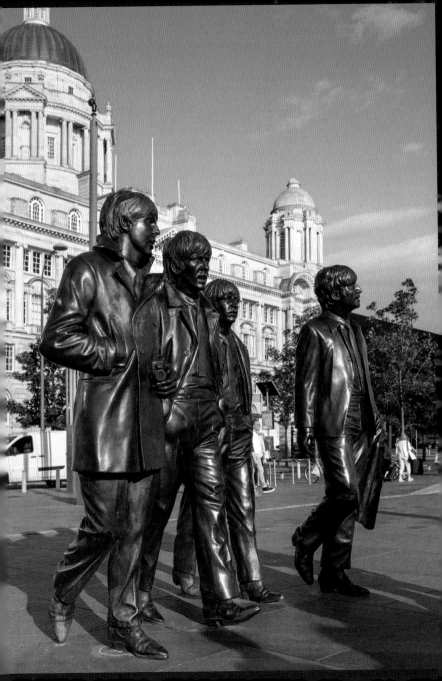

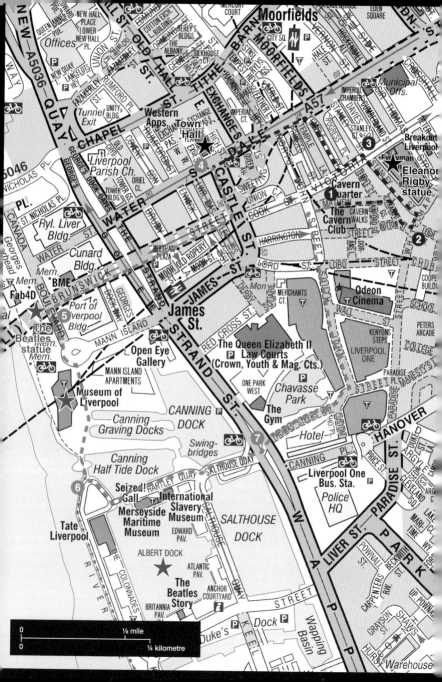

❶ Start at The Cavern Club which was inspired by a Parisian Jazz Club called Le Caveau. Opposite is the Cavern Wall of Fame, listing the bands who have played at the Cavern since it opened in 1957. Walk past the Cilla Black statue, pausing to look up at the Arthur Dooley sculpture *Four Lads Who Shook the World*. Continue down Mathew Street, watching out for the 'Blue Meanies' above you! Pass the Grapes pub where the Beatles used to drink and the George Martin mural next to the doorway of the authentic Liverpool Beatles Museum. When you reach a Beatles souvenir shop with a Beatles statue above its doorway, bear right into Rainford Gardens. Pass the White Star pub, named after the shipping line that launched the ill-fated *Titanic* in 1912, which was registered in Liverpool. The pub has a 'snug' room which was where John Lennon and other Liverpool musicians were paid by their first manager, Allan Williams. Continue into Button Street.

❷ At the end of the road, turn left onto Whitechapel to see the statue of the Beatles' manager Brian Epstein, opposite the former location of his record store NEMS (North End Music Stores). Take the next left into Stanley Street and on your left is a blue plaque marking the former Frank Hessy's music shop, which sold instruments to the Merseybeat era bands. Further along Stanley Street is the *Eleanor Rigby* statue ★. The song 'Eleanor Rigby' was inspired by a headstone at St Peter's Church in the suburb of Woolton, the same church where John Lennon was introduced to Paul McCartney in 1957.

❸ At the top of Stanley Street, turn left and cross over Victoria Street. Turn right into Temple Street to find the plaque on the former Iron Door club, another early Sixties music venue where bands such as the Searchers played. Continue to the top of Temple Street and turn left onto Dale Street, arriving at Liverpool Town Hall ★ where the Beatles waved to crowds of screaming fans from the balcony after their world tour in 1964. The foyer is often open and inside you will find brass wall plaques listing those who have been awarded the Freedom of the City, including John Lennon, George Harrison, Paul McCartney and Richard Starkey. There are also plaques for other 1960s Liverpool singers like Gerry Marsden, who wrote 'Ferry Cross the Mersey', as well as for politicians, football managers and supporters, and others who have significantly contributed to the city.

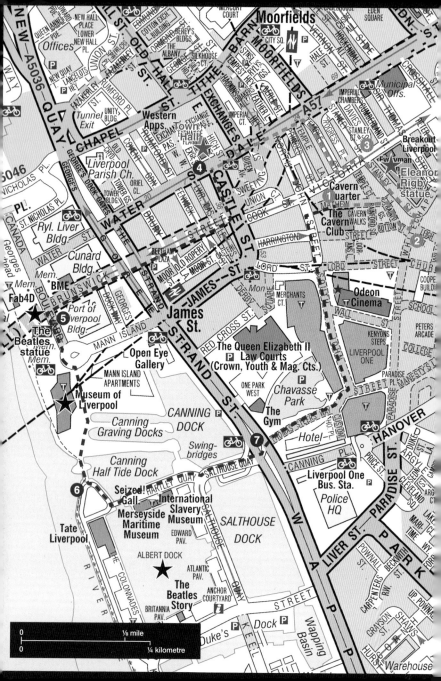

4 Turn left to walk down Castle Street then take the first right onto Brunswick Street. Cross over The Strand dual carriageway and continue onto the Pier Head to the Beatles statue ★ unveiled in 2015. Look out for secret details such as acorns, picked up outside the New York Dakota building, in the clenched hand of John Lennon and the number 8 underneath Ringo's shoe representing Liverpool 8, the area where he was born. The building on the riverside is the Mersey Ferry Terminal (officially The Liverpool Gerry Mardsen Ferry Terminal). The Beatles appeared on the *Royal Iris* ferry four times in a series of Riverboat Shuffle performances. The current Dazzle Ferry is a multi-coloured design by Sir Peter Blake, creator of the album cover for *Sgt. Pepper's Lonely Hearts Club Band*.

5 Walk away from the statues, with the three principal waterfront buildings on your left, towards the large white building, the Museum of Liverpool ★ . If the museum is open, you can see the Wondrous Place exhibition, including the original stage on which John Lennon was introduced to Paul McCartney. There are various Beatles and other music-related exhibits, and a panoramic Beatles film. Leave the museum passing the city's mascots, the Superlambananas, and walk towards the red brick warehouses of the Royal Albert Dock ★ .

6 After crossing a swing bridge you will arrive at the Billy Fury statue. The popular Liverpool rock'n'roll singer's real name was Ron Wycherley and he went to school with Ringo Starr. Now head for the tall brick chimney of The Pumphouse pub and continue out of the dock.

7 Cross Strand Street and continue up Thomas Steers Way into the open-air Liverpool One shopping centre. Turn left after the pedestrian entrance to the car park and carry on to the end of the walkway. Exit the shopping centre via steps onto North John Street and on your right look out for the four Beatles statues above the Hard Days Night Hotel, which is just before the turning into Mathew Street, where the walk ends. Pop inside for refreshments and continuous Beatles music. You might hear 'The End' by the Beatles, of course!

⒜⒵ walk three

Views Old and New

Spectacular vistas and old pubs in the city centre.

A sleek steam-powered liner slides majestically at high tide into its berth, floating proudly alongside the new waterfront buildings designed to be its impressive backdrop. That was over a century ago. Those buildings – known collectively as the 'Three Graces' – are now part of Liverpool's history.

Fast forward a hundred years and the first decade of this century saw renewed development in the area, aided by the city's term as the European Capital of Culture in 2008. The Liverpool One retail development was opened in 2008, the new Museum of Liverpool was realized along with another previously inconceivable idea, the Leeds & Liverpool Canal extension.

This jaunt through the city centre gives you the opportunity to view these sights from high up as well as from street level. Some of the once-new buildings were the subject of envy by their smaller neighbours on account of their size. Other new builds were initially criticized for spoiling the view. We will see the city centre's oldest building, the Bluecoat, as well as one of its tallest, St Johns Beacon, and pass a few old Liverpool pubs along the way.

The waterfront provides views of the historic Royal Albert Dock, the monumental Royal Liver Building and its once-affronted neighbour, The Port of Liverpool building. We'll also walk through the 'vista spoilers' to the wonderful Museum of Liverpool which has the best view in town: the river, of course!

start / finish	The Beehive pub, Mount Pleasant
nearest postcode	L3 5RY
distance	2½ miles / 4 km
time	1 hour 30 minutes (excluding ferry trip)
terrain	Paved roads and walkways (some uneven), steps, escalators, and lifts.

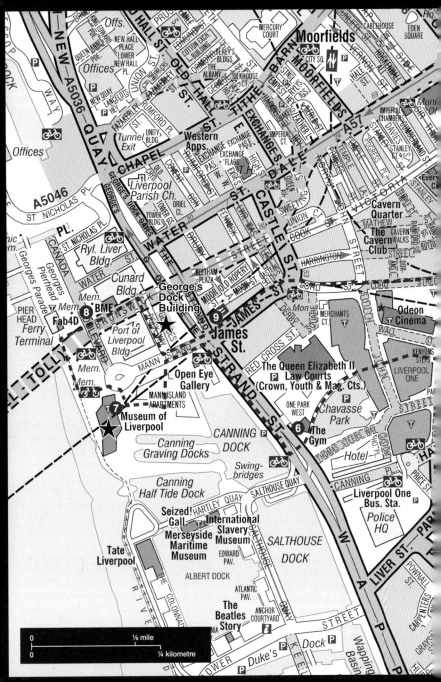

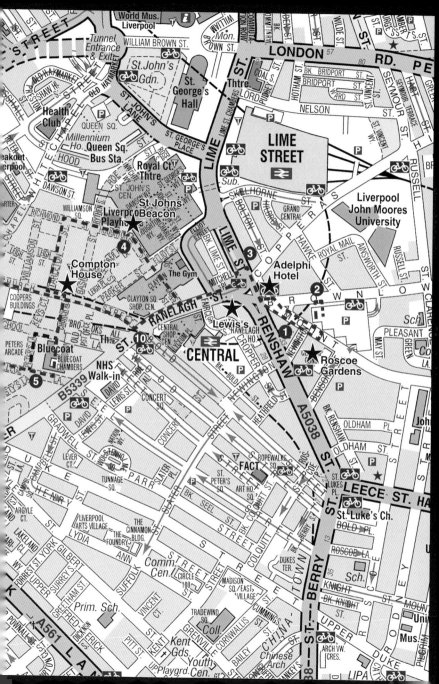

❶ Start at the Victorian Beehive pub at the bottom of Mount Pleasant, a street that dates from the mid-1750s. Walk up the road until on your right you reach Roscoe Gardens ★, with the domed monument. The garden was named after William Roscoe, one of the most influential of Liverpool's great and good, who was born in the Bowling Green Inn on this street in 1753. Cross Mount Pleasant into the multi-storey car park via the narrow lane to the left of it (the pedestrian entrance is at the end of the lane, round to the right). Climb the stairs, or take the lift to the top, to enjoy a panoramic view that spans nearly 200 years of city centre development. Look out for: Lime Street Railway Station (1836), the old Royal Liverpool Hospital (1978), the new Royal University Hospital (2022), the Metropolitan Cathedral (1967), Liverpool Cathedral (1978), St Luke's 'Bombed Out' Church (1832), Methodist Central Hall (1905), St Johns Beacon (1969) and the Adelphi Hotel (1914).

❷ Return to Mount Pleasant and descend the hill. Cross over to the Adelphi Hotel ★ facing the former Lewis's building ★. This famous department store was rebuilt after the Second World War Blitz. The statue above the doorway – *Liverpool Resurgent* – once marked a popular meeting place. The statue caused quite a stir when it was unveiled in 1956 due to its full-frontal nudity, hence its nickname 'Dickie Lewis'. Spot the three bronze panels above the door.

❸ Cross Copperas Hill, at the far side of the Adelphi, and Lime Street, then turn down Ranelagh Street, passing two late-19th-century pubs, The Central Commercial Hotel and The Midland. Turn right through Clayton Square (named after a city elder, Sarah Clayton, 1712–1779) and out the other side. Towering above you is St Johns Beacon ★, once a revolving restaurant. Sixty seconds in the lift takes you to the top for an incredible 360-degree view of Liverpool (fee applies).

❹ Exiting the Beacon, turn right to Williamson Square. Continue along the square and turn left at Tarleton Street. On the right you will pass the cosy Carnarvon Castle pub, alluding to Liverpool's Welsh heritage. At Church Street, turn left. Look up at Compton House ★, the first purpose-built department store in Europe. Opposite is Church Alley – turn down here to the Bluecoat arts centre at the end. The building dates from 1717. Walk through the building and the peaceful courtyard garden to College Lane. If closed, turn right to walk past the Bluecoat and take the first left along Peter's Lane to join College Lane at the end.

❺ Turning right, walk to the end of the lane and towards the multi-flight stairway – the hidden escalator is behind. This is part of the Liverpool One retail/leisure development which transformed the city centre in 2008, linking Church Street to Albert Dock using the existing street system.

Ascend and walk through to the upper deck. This leads you to a grassed former bomb site called Chavasse Park after Noel Chavasse, a local First World War hero. Walk through the park towards the tallest building and take the stairs to road level. Ahead of you, you can see: Albert Dock (1846), the Pump House (1878) and the distinctive red columns of the former Dock Traffic Office (now part of the International Slavery Museum).

6 Cross over Strand Street and turn right, passing the tall modern black building. Turn left at the brick-built pumping station (1899) with the words 'All the Worlds Futures' on it and walk through the glass atrium separating the two black granite cuboids (the Longitude and Latitude buildings). Pass the Open Eye Gallery on the left, which is a worthwhile visit, and walk alongside the new Leeds & Liverpool Canal extension to the Museum of Liverpool (2011) ★. For a quick visit, ascend to the second floor and turn right to The People's Republic gallery, then find the scenic Pier Head viewing window.

7 Exiting the museum, hug the building, (it's often windy) towards the Gerry Marsden Mersey Ferry Terminal, passing the Leeds & Liverpool Canal extension as well as the Naval and Merchant Navy Memorials. You can see Cammell Laird's shipyard across the river. A ferry has been operating here since the 1400s, originally from Birkenhead Priory. If time allows, take a return crossing. The view of the city

from the river is wonderful. Facing the river are the Three Graces. On the left, with the Liver Birds on the top, is the Royal Liver Building (1911). The Cunard Building (1917) is in the middle. To the right, the domed Port of Liverpool Building (1907) formerly housed the Mersey Docks and Harbour Board, which owned the Liverpool dock system.

8 Take the road between the Cunard and Port of Liverpool Buildings then turn right. The Art Deco building on the left is called George's Dock Building ★ and is a ventilation tower for the Mersey Tunnel. Look for the black basalt figures called Night and Day. Above them are designs that represent the road tunnel below. Turn left at the end and cross The Strand. The red and white striped building in front of you is Albion House, which was the headquarters of the White Star shipping line.

9 Ascend James Street and continue walking straight ahead, past the Queen Victoria Monument (1906), onto Lord Street and then back to Church Street. Pass the statues of brothers Sir John and Cecil Moores, of Littlewoods and football pools fame.

10 At the crossing, you will be facing the Lyceum (1802), a library and later gentlemen's club. Turn left up Ranelagh Street. Opposite the end you will see The Vines (1907), once a well-known gin palace. Cross in front of the Adelphi Hotel again and ascend Mount Pleasant to return to The Beehive.

▲Z walk four

Waterfront Walk

A tour of Liverpool's maritime heritage.

Liverpool's iconic waterfront buildings were planned to impress those arriving by ship when they came to do business with the city. This circular walk around the Pier Head and Royal Albert Dock areas allows you to admire the architecture, with the option to take the famous Mersey Ferry to fully appreciate the magnificent view from the river.

The river shaped the city's fortunes dramatically. When the nearby River Dee ports at Chester and Parkgate silted up, Liverpool was quick to seize the opportunity to become the northwest's principal port and capitalize on overseas trade. It built the world's first commercial wet dock in 1715 (which has since been filled in). As trade increased over the years, the waterfront had to be re-engineered to build an extensive dock system for cargo ships and landing stages for ferries and transatlantic liners.

Liverpool lived up to its status as the second port of the British Empire by constructing one of the world's most impressive entranceways to a city, on the Pier Head, which was once just a small jetty. The three magnificent architectural masterpieces of the Royal Liver Building, the Cunard Building and the Port of Liverpool Building delight today's cruise liner passengers, who can enjoy the ease of stepping off the gangplank and walking effortlessly into town.

start / finish	Museum of Liverpool, Pier Head
nearest postcode	L3 1DG
distance	2½ miles / 4 km
time	1 hour 30 minutes (excluding optional museum tours and ferry trip)
terrain	Pavements and uneven cobbles. Steps.

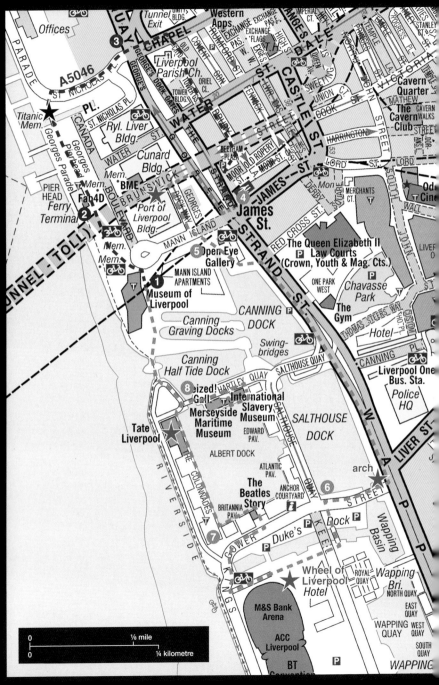

① Start at the Museum of Liverpool, which is worth a visit if open (particularly The Great Port gallery and the second floor viewing window). Walk towards the Pier Head keeping the River Mersey on your left and passing the Leeds & Liverpool Canal link extension, which was opened in 2009. The main canal to Leeds was completed in 1816 to transport cotton for processing in Lancashire and Manchester, and coal to Liverpool. Walk towards the ferry terminal building, passing a series of memorials. The Mersey Ferry has operated for 700 years, an hour's row from its initial destination of Birkenhead Priory. If you have time, take a direct commuter service, or a 50-minute river cruise. Either is a must-do voyage.

② In front of the Ferry Terminal is the Beatles statue, which was unveiled by John Lennon's half-sister Julia Baird in 2015. Behind and to the right of the statue is the domed Port of Liverpool Building (1907), former headquarters of the Port Authority, once the most influential organization in the city. To its left is the Cunard Building (1917), formerly the shipping line's head office and terminal. Far left is the Royal Liver Building (1911), with a Liver Bird (a fictitious bird and the symbol of the city) sitting atop each tower. A roof-top tour is well-worth the climb if you have the time. Ironically, the owner of Everton Football Club part-owns the building, although the Liver Bird is the symbol of the rival team Liverpool. Continue along the maple-lined Canada Boulevard,

passing the Liver Building, towards the golden flame on top of the Art Deco *Titanic Memorial* ★ , by Goscombe John. This commemorates the sacrifice made by the ill-fated ship's engine room crew. With the cruise terminal on your left, walk away from the river towards the Crowne Plaza Hotel.

③ Cross New Quay past the Mersey Tunnel's Pier Head exit, above which is the brutalist 'Sandcastle Building', once home to the local Daily Post and Echo newspapers. Turn right at the hotel shaped like the bow of a ship then immediately left, noticing the Simpson Drinking Fountain (1885) in the wall opposite. Turn right into the churchyard of St Nicholas Church, known as the seafarers' church. Walk around to the Blitz statue by Tom Murphy, symbolizing a lady safely holding her daughter whilst trying to call her son down to get to safety in an air raid shelter. Look up to see a golden weathervane on the tower that was once an important navigation point. There is also a secret white Liver Bird on top of the nearby Harrison Line Shipping Office, Mersey Chambers. Exit the gardens via the narrow Tower Gardens, then cross Water Street to Drury Lane. Bear right to Beetham Plaza, where you will find one of only two kinetic fountains in the UK, with water buckets filling each other to eventually tip into a pool. Explore! It was designed by Richard Huws and built by apprentices at Wirral's Cammell Laird Shipyard in the 1960s. Walk through the plaza, down the steps and continue along The Strand.

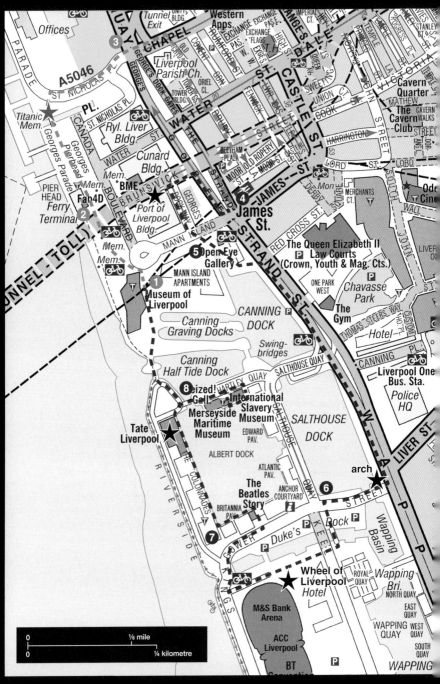

4 Cross at the traffic lights to George's Dock Building. Built in 1931 by Herbert J. Rowse, this is an Art Deco ventilation shaft for the first Mersey Road Tunnel. Note the bright green toll collection booth next to the building. Enter the domed Port of Liverpool Building ★ (open during weekday office hours). In the atrium, stand on the compass and look up to admire the quality of the marble and the stained glass. Take the left corridor out of the building and look across The Strand to the striped building, Albion House, once the head office of the White Star Line which owned *Titanic*.

5 Cross to the glass atrium of Equator House between two black buildings called Longitude and Latitude. This development interrupted the view of the waterfront buildings and was much criticized. Walk through the atrium and left past the Leeds & Liverpool Canal extension. Cross a small bridge then turn right at Strand Street and walk alongside Canning Dock. Continue past Salthouse Dock and through a reconstructed stone arch ★ from a salt factory wall. Turn right after the arch and walk past the car park until you reach two bridges side by side over Duke's Dock on the left.

6 Take either bridge. Passing the Wheel of Liverpool ★ , walk towards the river alongside Dukes Dock. Turn right then right again to walk back up the side of Albert Dock (1846). Turn left at the Beatles Story to go through the glass doors into the interior and turn

left along The Colonnades. This Grade I listed dock operated for 100 years from the days of sail to steam, after which it became too small. It was nearly demolished in the 1960s, but was regenerated and re-opened in 1985.

7 Continue to Tate Liverpool ★ , named after Henry Tate, a wealthy Liverpool art collector, philanthropist and sugar merchant. Pass the giant multi-coloured hammer, *Liverpool Mountain*, and turn right over the lock bridge. The Maritime Museum together with the International Slavery Museum (check opening days) is well worth a visit. Continue along the cobbled quayside towards the Pump House pub, the former hydraulic pumping station (1875). Turn right in between the Dock Traffic Office and the Maritime Museum. During office hours you can take a short cut through the museum using the door next to a canon called the One O'Clock Gun. Otherwise retrace your steps.

8 Go back over the lock bridge and turn right towards the Museum of Liverpool, passing the Piermaster's House. Walk over the sea lock bridge. Bear right and pass The Carters Working Horse Monument and an original propellor from the Cunard ship *Lusitania* (1907). The dry docks surrounding the Great Western Railway shed can be explored, with exhibits of dock machinery. Return to the museum to see the Superlambananas, sculptures linking the imaginary genetic modification of two of Liverpool's common cargoes: wool and bananas.

ᴀZ walk five

Sugar, Slavery and Shame

Reminders of the slave trade on the city centre streets.

Liverpool's fortunes are rooted in slavery. During the 18th century, the port strengthened its position in the triangular trade: merchants sailed goods to West Africa and traded these for enslaved people, who were transported in horrific conditions to the Americas and forced to work on colonial plantations. The produce was then shipped back to Liverpool to be sold. A key slaving port in Europe, Liverpool was ruthless in its pursuit of profit from this activity.

Successful companies and learned institutions were built on wealth generated from slavery. Banking, insurance, sugar refining, import and export companies, trading exchanges, construction and shipping trades all flourished as a result. And although the slave trade was officially abolished in 1807 (with the help of some influential Liverpool residents), the city fought for its extension. Illegal trading continued for several decades.

The enduring impact of the slave trade on the landscape of Liverpool is explored on this circular walk. We start at the International Slavery Museum, which is worth a visit to learn more about the history of West African culture, forced migration, slavery, life on a plantation and abolition. We will see the dock built to receive the imported goods (sugar, cotton, tobacco and rum), the fine Georgian houses built by the wealthy merchants and the street names linked to those involved.

start / finish	International Slavery Museum, Royal Albert Dock
nearest postcode	L3 4AQ
distance	5 miles / 8 km
time	2 hours 30 minutes (excluding museum visit)
terrain	Pavements, some uneven paths, steps, one steep incline.

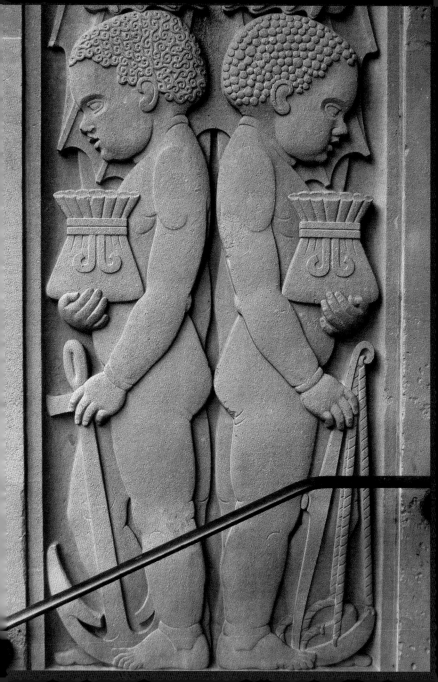

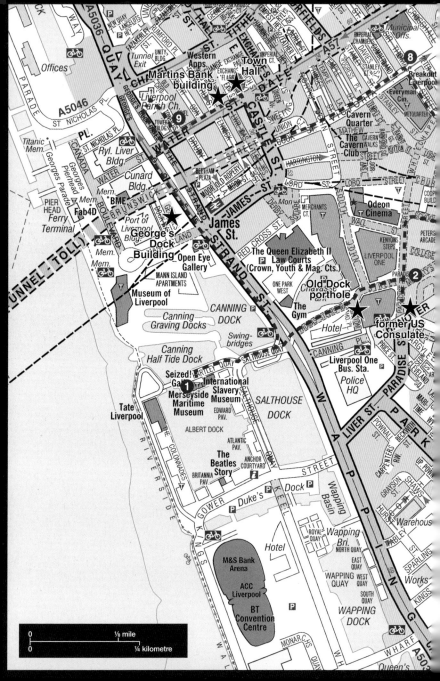

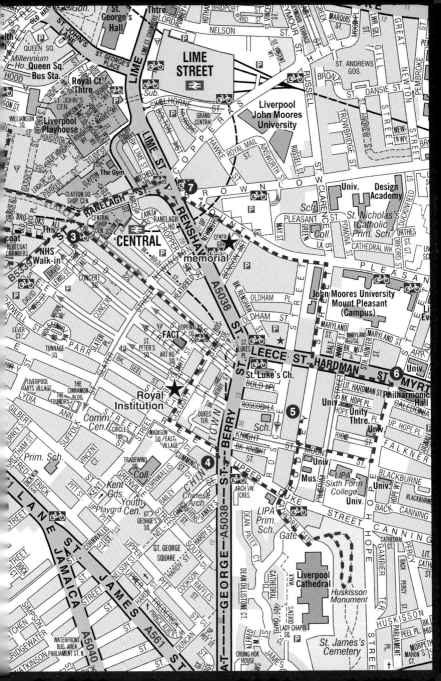

❶ From the International Slavery Museum, walk past the Pump House pub then Salthouse Dock on your right, named after John Blackburne's salt works (more later), and Canning Dock to your left (after former prime minister George Canning, who campaigned in favour of freeing enslaved Africans). Cross the Strand Street dual carriageway and continue past the Hilton Hotel up Thomas Steers Way, to the Old Dock porthole ★ in the ground near the junction with Customs House Place. The remains of the Old Dock (1715) are beneath (tours available from the Maritime Museum). The Old Dock itself was frequented by slaving ships. Continue under the walkway to Paradise Place.

❷ Turn right and look for the building on the left with the large golden eagle (no. 51) ★. This was once the Consulate of the United States, inaugurated in 1790 with its first consul James Maury. At this time, Liverpool was the country's main port involved in the transatlantic slave trade. The building originally stood at the side of the Old Dock. Turn back along Paradise Street. Turn right into School Lane and walk to the Bluecoat (1717), the oldest surviving building in the city centre. It was built by sea captain Bryan Blundell as a charity school for orphans, largely with the profits of slavery. Many orphans were indentured as sailors, who often worked in the slave trade. The school moved to new premises in 1906 and the building is now an arts centre. During opening hours, you can walk through the Bluecoat's café and garden and turn left onto College Lane then left again onto Hanover Street. Out of hours, continue up School Lane and turn left at the end onto Hanover Street.

❸ Turn right onto Bold Street, once the shopping street of wealthy merchants and their families. It was named after Jonas Bold, sugar merchant, and one-time mayor of Liverpool. At the foot of Bold Street is the former Lyceum Club and library, which opened in 1802. Many founding members had links to the slave trade. The land in this area was once home to the ropemaking works of slave traders Joseph and Jonathan Brooks. Towards the top of Bold Street, turn right into Colquitt Street and continue straight on over two crossroads as far as no. 24. This building was constructed in 1799 as the home of Thomas Parr, owner of slave ship *The Parr*. After the ship's demise, the building was sold to the Liverpool Royal Institution (1817), which promoted literature, science and the arts, and of which Parr was a founding member. Pass Parr Street and turn left onto Duke Street, crossing it at the traffic lights.

❹ Cross George Street then ascend Upper Duke Street to the Anglican Cathedral. Walk past the small classical building on the left (The Oratory) then, keeping left, descend the grave-lined path to St James Gardens (daytime opening hours). Keep to the right until you reach the domed circular mausoleum. Standing in front of the

mausoleum gates, walk 90 degrees anticlockwise, then the third of three slabs to your right is the grave of Edward Rushton (1756–1814), an indentured young sailor and eventually second mate on a slave ship. Disgusted with the brutal treatment of enslaved people, he was charged with mutiny. He became a staunch and vocal abolitionist, and though he lost his sight, was the uncompromising editor of the *Liverpool Herald* and the founder of the Liverpool School for the Blind. Return to Upper Duke Street and cross to Rodney Street.

5 No. 62 Rodney Street is where the most prolific and profiteering enslaver and plantation owner in the country lived, the MP John Gladstone. He gained more government compensation for ceasing his slavery businesses than any other British slave trader. His son William Ewart Gladstone, Liberal MP and four-time prime minister, was born in this building. Turn back as far as Mount Street then climb the hill to Hope Street. Walk past the sculpture of suitcases (evoking a time of huge emigration from Liverpool) to view Blackburne House opposite. Styled as a French chateau, with its high wall and grounds, it belonged to John Blackburne, who traded in enslaved Africans and owned the salt works at Salthouse Dock. Turn left along Hope Street – there are inscriptions on the former school for the blind founded by Edward Rushton and, around the corner on Hardman Street, above the door are carvings of basket weaving and other crafts taught at the school.

6 Walk down Hardman Street then turn right into another section of Rodney Street. The first United States Consul James Maury lived at no. 4. Maury worked for 39 years developing Liverpool's US transatlantic business interests, which included slavery. Continue along Rodney Street to Mount Pleasant and turn left. Walk down Mount Pleasant until railings and gardens appear on the left. The low, domed memorial ★ has a plaque to William Roscoe on the right-hand side. Roscoe's many interests included banking, law, the arts and the foundation of academic institutions and libraries. A vocal abolitionist, he once caused a riot amongst Liverpool slavery supporters. However, he was also in favour of compensating enslavers for their loss of livelihood. Continue to the foot of Mount Pleasant and turn left.

7 Cross over to Lewis's building, keeping right, then turn left onto Ranelagh Street, walking to its junction with Church Street. Walk down Church Street and take the third right into Tarleton Street, named after the Tarleton family, three generations of slave traders. Turn left onto Richmond Street and continue ahead across Whitechapel onto Sir Thomas Street, named after Sir Thomas Johnson, mayor in 1695 and one of the earliest documented slave traders.

8 At Victoria Street, turn left. Here you will pass the Bank of Liverpool building (1831) on the right. Its early investments came from cotton interests from America, which did not abolish slavery until 1865, nearly 60 years after Britain. Walk along to Castle Street and turn right. At the street's end, the Town Hall (1754) ★ was originally built as a trading exchange with council offices above. On the right-hand side of the building, above the second arched window, there is a frieze depicting an African woman's head, emblematic of Liverpool's role in the business of slavery. The Hall itself was built by the Brooks family, part of the slave-trading elite of the city. Turn left towards the river and on your right is the former Martins Bank building (1932) ★. In the recess of the second doorway you will see stylized Art Deco reliefs of two enslaved boys, manacled and carrying money bags, the sculptor Tyson Smith making a symbolic link between slavery and the origins of the banking industry in Liverpool.

9 Continuing along Water Street, turn right at Tower Gardens and walk through to the churchyard. Twenty steps after the gates and three paving stones from the left of the garden you will see a pavement memorial stone to Abell, the first recorded Black resident of Liverpool, who was buried at St Nicholas Church. Leave the churchyard via the steps under the arch or use Tower Gardens steps. The white building to the left was the site of the Goree Tobacco Warehouses, destroyed in the 1941 Blitz. They stored the lucrative cargo, farmed by enslaved Africans on plantations and processed in Liverpool. Cross The Strand, turn left and continue as far as the tall Art Deco Mersey Tunnel ventilation shaft (George's Dock Building) ★. At the corner of the building, there is a street sign for Goree, which was a slave-trading post in Senegal. Continue past Canning Dock and return to the International Slavery Museum.

AZ walk six

Victorian Liverpool

Nineteenth-century splendour in the city centre.

Some of Liverpool's grandest city centre architecture was built during the reign of Queen Victoria, between 1837 and 1901. Taking in some of the finest examples – and more besides – this circular walk starts from the magnificent Lime Street Railway Station. Although first opened in 1836, the station buildings were enhanced over subsequent decades and still the architecture will impress, as it was specifically designed to make a statement to visitors arriving on the world's first passenger railway from Manchester.

We then follow a route rich in commercial heritage with many clues as to the original uses of the buildings, most of which have since been converted into hotels. There are secret codes, fossils and engravings on the pavements as we pass along some of the oldest streets in the city.

Open to the public are St George's Hall, with its Victorian jail and music hall, and the Central Library's stunning circular Picton Reading Room (though you'd better not cough, or the echo will reverberate around!). Victorians in Liverpool were never far from a drinking house and there are still a number of ornate pubs and gin palaces standing, which will delight the connoisseur on this walk.

start / finish	Liverpool Lime Street Railway Station
nearest postcode	L1 1JD
distance	1½ miles / 2.5 km
time	1 hour 30 minutes
terrain	Level, paved roads and walkways. Steps.

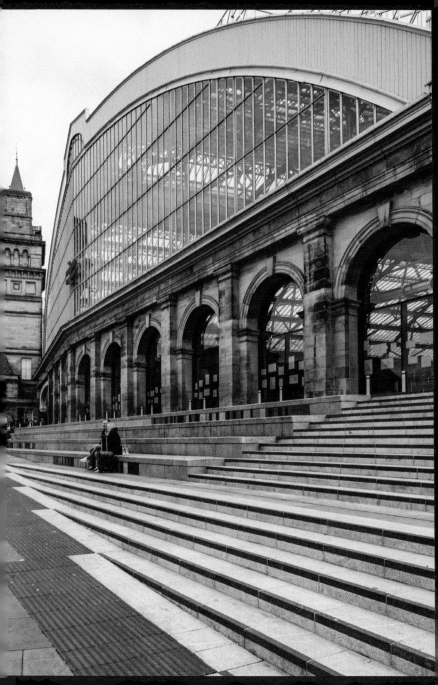

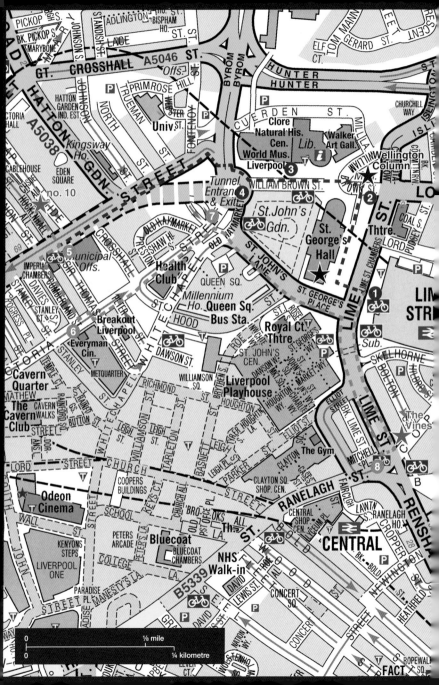

1 Leave the station concourse, passing two statues: Ken Dodd, a Liverpool comedian, and Bessie Braddock, a 20th-century local Member of Parliament. There are secret engravings in the paving stones as you make your way down the steps from the station. Cross over Lime Street to St George's Hall (1854) ★, the large neoclassical building opposite. On the plateau in front, there are equestrian bronzes of Queen Victoria and Prince Albert. Separating those statues is the 1930 cenotaph carved by Herbert Tyson Smith, who has even included himself as a Master Mason showing the 'sign of reverence' with his thumb tucked away under his fingers. Continue along the plateau. Opposite St George's Hall is the newly refurbished North Western Hotel (1871), followed by the Empire Theatre.

2 Near the Wellington Column (1863) ★ there are quite a few fun secrets to look for. On the stone pillars around the column itself there are fossils; on the sixth pillar from the steps there is a radially symmetric creature which looks like a coral. To the left of the Steble Fountain (1879), carved into the pavement, there are curious old standard measurements, for example, feet, yards and chains, used by the Board of Trade. Turn left into William Brown Street. The Victorian buildings were funded by rich brewers, merchants and bankers. From right to left as you look down the street, the buildings are: the County Sessions House (1884), the Walker Art Gallery

(1877), the round-fronted Picton Reading Room (1879) and Central Library (1860). On the bottom corner is the World Museum (1853).

3 On the wall between the library and the World Museum there is one of ten plaques in the city acknowledging the links between local merchants and the wealth accrued in Liverpool through slavery. On the slate pavement leading to the entrance of the library are red letters spelling out a hidden phrase – the answer can be found in the Oak Room on a bookshelf next to the Audubon book *Birds of America*. Inside, the Picton Reading Room and the roof-top terrace are perhaps two of the city's best-kept secrets. Continue to the bottom of William Brown Street. To your left is a memorial to the ninety-seven Liverpool Football Club supporters who lost their lives at the 1989 Hillsborough disaster.

4 Facing you is the Art Deco entrance to the 1934 Queensway road tunnel underneath the River Mersey. This tunnel was used for a motorcycle chase in the film *Harry Potter and the Deathly Hallows*. Cross over to a green Art Deco building, Stanley House (1937), and continue along Dale Street. The street is rich in pubs noted for serving real ales – a favourite with locals is The Ship and Mitre.

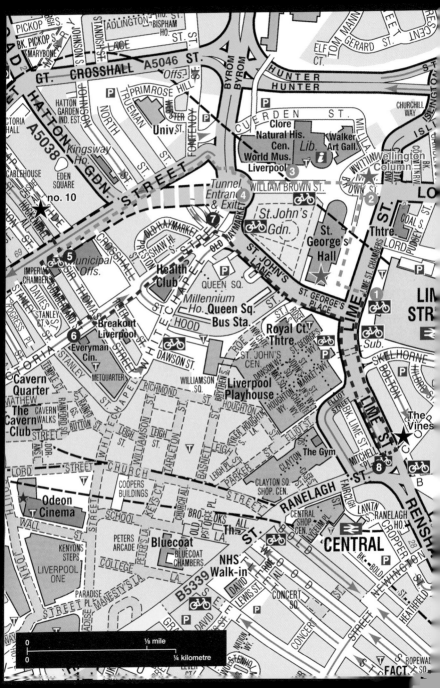

5 Further along you will pass the Victorian police cells on the corner of Cheapside and then reach the narrow Hockenhall Alley. Take a short detour down here to see one of the oldest remaining residential buildings in Liverpool at no. 10 ★, once a row of fishermen's cottages built in 1765. Return to Dale Street, pass the clock and spire of Municipal Buildings (1866) and turn left onto Cumberland Street. On reaching Victoria Street, opposite is a former Post Office. Opened in 1899, it has now been repurposed as a shopping centre and cinema.

6 Turning left along Victoria Street, above the entrance of the Sir Thomas Hotel you will see 'Bank of Liverpool' carved into the stonework. The bank had formed in 1831 from the cotton trade and even used to print its own money, and this building dates from 1882. Cross over and continue along Victoria Street, passing the huge doors of the former Midland Railway Goods Warehouse (1872), now the Conservation Centre for National Museums Liverpool. Further along, pass the rare flat iron-shaped Imperial Buildings (1879) now called The Shankly Hotel, after Bill Shankly the Liverpool Football Club Manager who in the 1960s led the club to promotion to the First Division.

7 Cross Whitechapel into St John's Lane, keeping St John's Gardens on your left, and you will pass Doctor Duncan's (another real ale pub).

Queen Victoria appointed Dr William Henry Duncan as the country's first Medical Officer of Health in 1847. He was tasked with improving the city's sanitary conditions to reduce the spread of disease. At the top of St Johns' Lane, keep right and cross the bus interchange towards the red brick Art Deco Royal Court Theatre (1938). Keeping left, pass the mural of comedian Ken Dodd and a 'kissing gate', and continue along Lime Street until you reach the ornate former gin palace, The Vines ★. This neo-baroque building, dating from 1907, replaced the original Vines pub that was opened in 1867. Opposite, on the Lewis's building (rebuilt 1956) is the *Liverpool Resurgent* statue by Jacob Epstein, made famous as the 'statue exceedingly bare' in the folk song 'In My Liverpool Home', performed by The Spinners.

8 Across the road is the Adelphi Hotel, which has a long list of distinguished guests including Charles Dickens, Franklin D. Roosevelt, Winston Churchill, the Beatles and Frank Sinatra. Inside, the Sefton Suite is a replica of the smoking lounge on the ill-fated liner *Titanic*. The current building is the third to occupy the site and was built in 1914. Turn back along Lime Street towards the railway station, just before which you will see the Crown Hotel. This Art Nouveau-style establishment opened in 1905 and has a very ornate interior. Carry on, returning to the starting point.

AZ walk seven

Beatles in the City

The city centre sites that inspired the songs.

The River Mersey played a prominent role during the Second World War in terms of shipbuilding, the import of supplies and secretly monitoring the movement of merchant ships and German U-boats during the Battle of the Atlantic. Returning sailors brought home records, American rhythm and blues merged with Hillbilly and a new raw music style was born. After hearing Elvis Presley and watching films like *Rock Around the Clock* in 1955, the lure was irresistible. Local boys like John Lennon wanted to play rock'n'roll, forming school bands with home-made instruments. A skiffle craze emerged and in Liverpool the music scene became known as 'Merseybeat'.

This circular walk starts from the former fruit warehouses, converted in 1957 to the Cavern Club and made famous in the 1960s by John Lennon's band the Beatles. 'Do You Want To Know A Secret' was a Beatles song and as you continue the walk, more clues are revealed as you learn why the Beatles shot to fame. You will see the birthplace of the Beatles' manager Brian Epstein as well as the schools and colleges attended by bandmates John Lennon, Paul McCartney and George Harrison.

Along the way, you will pass the Georgian houses built in the mid-1700s by the wealthy merchants. These streets are now frequently used as filming locations. The climax of this walk is written in the lyrics of a Liverpool folk song: 'If you want a cathedral, we've got one to spare'… all will be revealed!

start / finish	The Cavern Club, Mathew Street
nearest postcode	L2 6RE
distance	2¾ miles / 4.5 km
time	2 hours
terrain	Paved roads and walkways. Steps and an incline to the cathedrals.

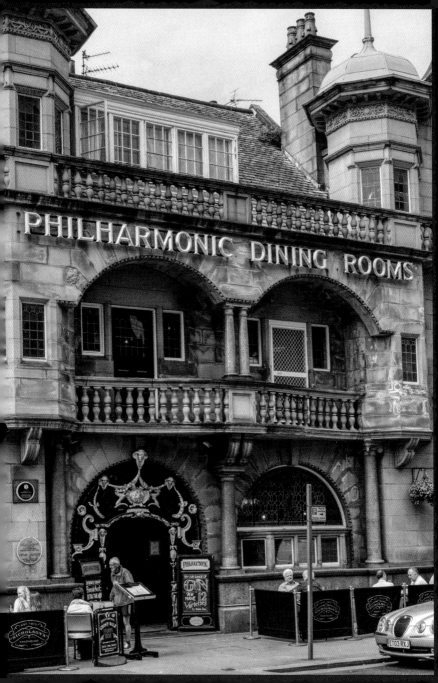

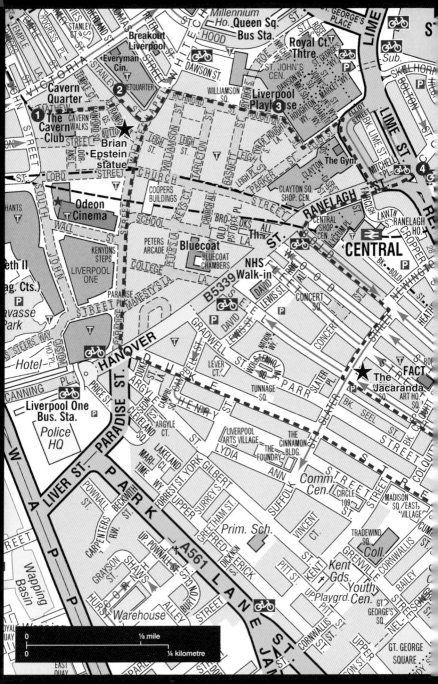

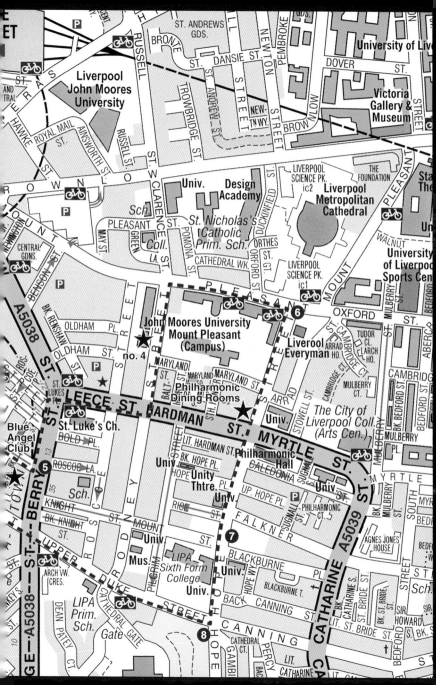

1 Start at the Cavern Club, where John Lennon's band the Quarrymen played on 7 August 1957 and the Beatles played 292 times. Walk towards the Cilla Black statue, passing a mural of George Martin, the producer for EMI Parlophone who signed the Beatles to the record label. Next, on the red doors of a former warehouse, are the names Pete, John, Paul, George, Ringo. This is the Liverpool Beatles Museum, opened by Pete Best's half-brother Roag. Pete Best was the Beatles' original drummer who was sacked by Brian Epstein, their manager, in 1962 despite his admirers in the Cavern chanting, 'Pete forever, Ringo never!'. Pete and his mother Mona made a significant contribution to the early success of the band and the museum is well worth a visit.

2 At the end of Mathew Street, turn right onto Stanley Street and then left onto Whitechapel, pausing to look at the Brian Epstein statue ★ , opposite the former site of his record shop NEMS (North End Music Stores). Continue along Whitechapel and turn right onto Richmond Street. The 1930s building on the corner was Rushworth and Dreaper, the music store where Paul McCartney, realizing he couldn't sing while blowing into his trumpet, swapped it for a German guitar. In 1962 John and George both bought Gibson guitars here, imported from Chicago. Looming in the distance is the 450-foot (138-metre) high St Johns Beacon, a paid attraction with stunning views from the top.

3 Pass St Johns Beacon and as the pedestrian area widens, turn left and climb a set of steps to face a pub on the opposite corner, which was formerly Reece's Café, where John Lennon had his wedding breakfast after marrying his art school sweetheart Cynthia Powell in 1962. At the top of the steps, turn right onto Great Charlotte Street and then turn left onto Ranelagh Street. Facing the top of the road is the Adelphi Hotel on Lime Street. The hotel has hosted many famous people including the Beatles and Brian Epstein. The street inspired John Lennon to include the Liverpool folk song 'Maggie May' on the *Let it Be* album with the lyric 'She'll never walk down Lime Street anymore'.

4 Turn around to walk back down the hill past Central Station and turn left onto Bold Street. Walk up Bold Street, turning right onto Slater Street, where on your left is The Jacaranda pub ★ . John Lennon and his band, then called the Silver Beetles, played the Jacaranda about twelve times in 1960. This resulted in the club owner, Allan Williams, becoming their manager and the opportunity to play in Hamburg, Germany. Turn left onto Seel Street and continue to the top to the Blue Angel Club ★ . This is the second of Allan Williams' venues, formerly known as The Wyvern.

5 Turn left onto Berry Street to the 'Bombed Out Church' of St Luke's. This church was bombed during the 1941 May Blitz. All the Beatles were born during the Second World War and were worried about being called up for National Service. Turn right past the church and walk up Leece Street, then turn left to see the plaque on no. 4 Rodney Street ★, the birthplace of Brian Epstein. Continue to the end of Rodney Street and turn left to no. 64 Mount Pleasant, the register office where John Lennon and Cynthia Powell married on 23 August 1962. Walk up Mount Pleasant to the Metropolitan Cathedral of Christ the King, which was built in 1967. Opposite the cathedral, behind the Medical Institute, is the former maternity hospital where John Winston Lennon was born on 9 October 1940.

6 Turn right onto Hope Street and walk to the Philharmonic Dining Rooms ★. This is the pub to which John Lennon was referring when he said the price of fame was 'no longer being able to have a pint in the Phil'. Continue along Hope Street but have a look to your left up Falkner Street. Brian Epstein had a flat here at no. 36. This Georgian street is frequently used to film period dramas such as *Peaky Blinders* and more famously became Baker Street in *Sherlock Holmes*. Staying on Hope Street, look left down Rice Street and you will see a pub called Ye Cracke, often frequented by John and his school friends.

7 Further along Hope Street are concrete suitcases, *A Case History*, with labels on Paul McCartney's and Stuart Sutcliffe's guitar cases. The building with the Mount Street sign on is the art college which John Lennon attended, whilst the adjacent building with four columns was the Liverpool Institute ★, Paul McCartney's and George Harrison's grammar school. Paul McCartney collaborated with Mark Featherstone-Witty to acquire his former school, creating the Liverpool Institute of Performing Arts (LIPA) in 1996. They later purchased the College of Art in 2012. Continue to the corner of Hope Street and, as promised, in the words of the popular folk song 'In My Liverpool Home': if you want a cathedral, we've got one to spare! Liverpool's Anglican cathedral is the world's fifth largest cathedral. In 1953 Paul's mother, Mary McCartney, took him to the cathedral to audition for the choir. After singing the Christmas carol 'Once in Royal David's City' he was told his voice wasn't strong enough!

8 To 'Get Back' (a Beatles song) to the Cavern Club, walk for just over half a mile (1 km) all the way down Upper Duke Street, which becomes Duke Street. At the bottom, bear left onto Hanover Street then immediately right at the old green dock gates onto pedestrianized Paradise Street and walk to the Brian Epstein statue, then turn left along Stanley Street to return to Mathew Street.

A̅Z̅ walk eight

Money for Old Rope!

Ropewalks and Chinatown.

Rope was traditionally made in fields, where the fibres were laid out over several hundred yards before being twisted together on a wooden-wheeled rack. As a major port and centre for shipbuilding, Liverpool needed a lot of rope (to give an idea of the scale, Nelson's flagship HMS *Victory* used 20 miles of rope in its rigging). The ropemakers bought long, narrow strips of land – known as 'ropewalks' – close to the docks. Although the fields are long gone, the street layout remains and the neighbourhood is named in honour of its former use.

Over time, the land was developed into merchant housing and warehousing, and this has now been converted into cafés, clubs, restaurants, bars, galleries and independent shops, creating the bustling, cultural hub on the edge of the city centre that we'll explore on this circular walk.

We also pass through vibrant Chinatown, buzzing with international students and locals alike. Liverpool has the oldest Chinese community in Europe: Chinese sailors were employed by Alfred Holt's Blue Funnel Shipping Line from the mid-1860s, importing silks, cotton and tea direct from Shanghai and Hong Kong. Many settled in the city, attracting wives by their reputation for being hardworking and 'teetotal'. The original Chinatown was slightly further south but was moved inland after parts were destroyed during the 1941 Blitz.

Along the way we'll see Liverpool's oldest church, Britain's first lending library, one of the city's oldest pubs and a secret location with panoramic views.

start / finish	Liverpool Central Railway Station, Ranelagh Street
nearest postcode	L1 4DJ
distance	2½ miles / 3.8 km
time	1 hour 30 minutes
terrain	Paved roads and walkways. Lift.

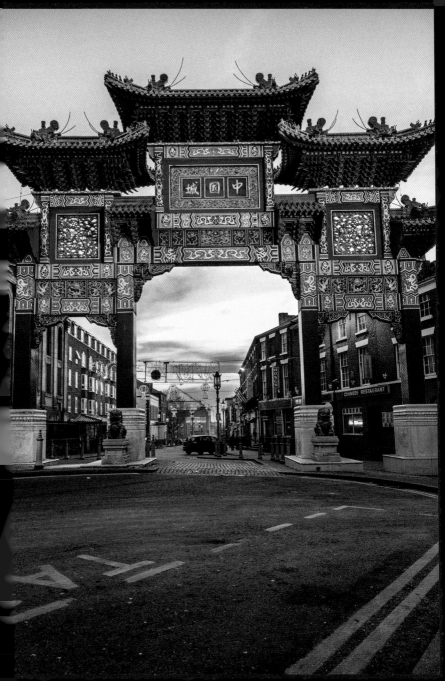

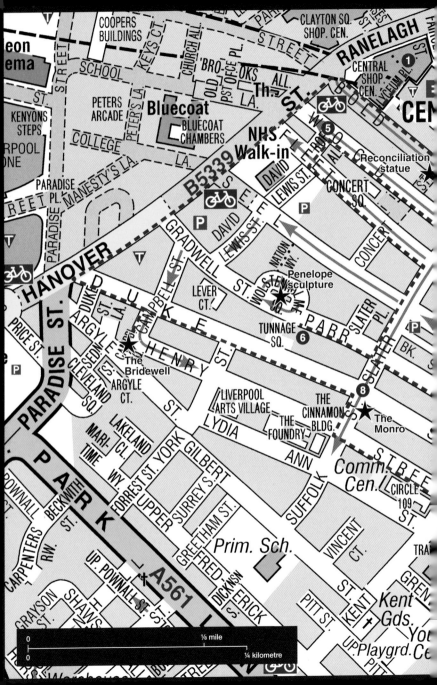

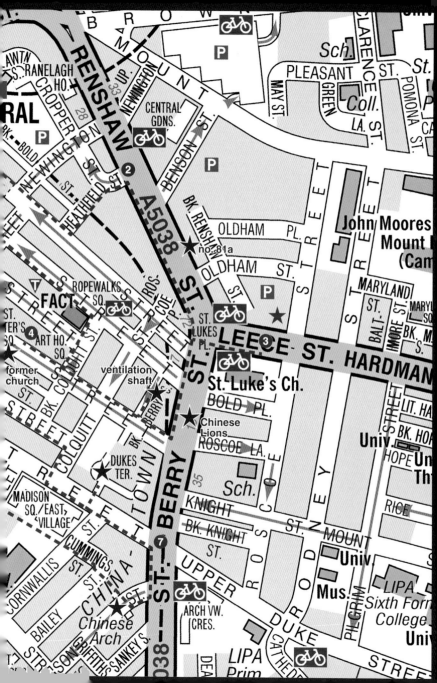

1 Take the Bold Street exit from Central Station and turn right to the Lyceum building, which opened in 1802 as England's first subscription library. Turn to walk uphill. The view up Bold Street to St Luke's Church at the top shows how straight this road is. Rope was measured from the top to the bottom of the street, as being the standard length of a rope for a ship. Pass the iron sculpture on your right, called *Reconciliation* ★. Identical 'huggers' were unveiled simultaneously in Glasgow and Belfast to show how sectarianism can be overcome by solidarity. Turn left at Heathfield Street, enter the car park and take the lift to the twenty-second floor to enjoy a stunning panoramic view. Spot the hills of North Wales, the Royal Liver Building and Liverpool Cathedral. Return to Heathfield Street. Continue to the end.

2 Turn right onto Renshaw Street. On the left-hand side of the road is no. 81a ★, the former offices of *Mersey Beat*, a national bi-weekly music magazine established in 1961 by Bill Harry, a fellow Liverpool College of Art student of John Lennon's, featuring news and articles about the city's burgeoning music scene. Continue to St Luke's Church (1831), known locally as the 'Bombed Out' church. It was designed by John Foster and firebombed in the 1941 Blitz. In the church gardens are memorials to the 1914 Christmas Day ceasefire of the First World War, the Irish potato famine of 1845 and the Republic of Malta's blockade during the Second World War.

3 Return to the junction with Renshaw Street and turn left along Berry Street to see a pair of Chinese Lions or Fu Dogs ★ . These Temple Lions mark the start of Chinatown. The one on the right is a male holding a globe, whilst the female on the left is nurturing a cub. Lampposts with dragons are painted in red and green to represent good luck and health, while the street signs are written in English and Mandarin. Turn right onto Seel Street to the Blue Angel, a former house. William Henry Duncan was born here in 1805 and later became Britain's first Medical Officer of Health. Opening as a music venue in 1960, when it was known as 'The Raz', the Beatles, Rolling Stones and Bob Dylan played here. Turn right into Back Berry Street. On the right, the walls and windows of this former stables are next to a brick ventilation shaft ★, built in 1874 for the underground railway. Return back down Seel Street.

4 Alma De Cuba is a quirky restaurant/bar inside Liverpool's oldest remaining church building, formerly St Peter's ★ , dating from 1788. Turn back up Seel Street and then left onto Back Colquitt Street to Ropewalks Square. At the near corner is FACT (Film, Art and Creative Technology). Turn left down Wood Street, passing The Swan Inn, open since mid-Victorian times and since the 1970s a welcoming yet uncompromising bikers', rockers', alternative and metal pub. On the opposite side are merchants' houses dating from 1792. Towards the

bottom of Wood Street, no. 16 is the former offices of the *Liverpool Mercury* newspaper. Above the door, two painted heads with wings represent Hermes the messenger god.

5 Turn left into Roe Alley, left into Fleet Street then take the third right into Slater Street. The Jacaranda ('The Jac') at no. 23 was opened in 1958 as a music venue by the Beatles' original manager, Allan Williams, and the band often played there. Turn right into Parr Street and walk to Wolstenholme Square to see *Penelope*, a sculpture created in 2008 by Jorge Pardo.

6 Return up Parr Street, passing the innovative dry café-bar The Brink, a successful initiative supporting staff in recovery from addiction. Turn right onto Colquitt Street then left onto Duke Street. Off to the left, Dukes Terrace ★, built in 1843, is Liverpool's only remaining example of back-to-back housing. Continue up Duke Street. At the end, turn right onto Great George Street then right into Nelson Street.

7 At 44 feet (13.5 metres), the Chinese Arch ★ forms the gateway to Liverpool's Chinatown and is the largest Imperial *paifang* outside mainland China. A gift from Liverpool's twin city, Shanghai, in the year 2000, it is decorated with over 200 dragons, thirteen of which are said to be pregnant. Next to it is a former congregational chapel which opened in 1841 and is now a contemporary arts

centre called the Black-E. Immediately before the arch, turn right down the narrow Cummings Street, alongside the former Scandinavian Hotel (1887) to the corner of Cornwallis Street, and pass the former Workshops for the Outdoor Blind, which opened in 1870. Continue into a small square to see two Superlambananas, mascots for Liverpool's 2008 European Capital of Culture year. Continue into Henry Street and turn right into Suffolk Street.

8 As you turn left onto Duke Street, notice The Monro ★ on the corner to your right. One of the city's oldest pubs (with great food), it has been open since 1817. Diagonally opposite, at no. 105, is the former Union Newsroom which opened in 1800. This became Liverpool's first public library in 1852. Walk down Duke Street and take the second left into Campbell Street to see another quirky pub, The Bridewell ★, built in the 1840s to accommodate drunken seamen. Charles Dickens was sworn in as a special constable here in 1860 whilst researching his book *The Uncommercial Traveller*. Return to Duke Street and turn left, then right onto Hanover Street. Turn right into Bold Street to return to Central Station.

ᴀᴢ walk nine

Ship to Shore

The South Docks, Baltic Triangle and sailors' town.

The Merseyside Maritime Museum sets the scene for Liverpool's heyday as a merchant shipping superpower. In 1880, 10,000 ships passed through its docks, the city awash with sailors and their yarns, embellished with a jar or two, while their vessels were quickly unloaded and loaded with cargoes of stone, coal, wood, machinery, fruit, textiles, grain, cotton, ice, sugar… This created casual employment for the stevedores, porters and labourers, who queued, daily, in their thousands in the hopes of securing a day's work.

The docks were surrounded by warehouses for storing the goods, while the adjacent neighbourhoods were developed by chandlers, merchants and manufacturers, taking advantage of their proximity to the docks. But steam ships needed larger facilities and smaller crews, and operations eventually moved to the deep-water container port downstream, leaving the old docks derelict and the warehouses abandoned.

This circular walk takes us from Royal Albert Dock to the regenerated South Docks of Duke's, Wapping, Queen's and Coburg. We return through the heart of the Baltic Triangle, named after the seafarers from Russia and Scandinavia who sailed into the South Docks, and now with a reputation as one of the 'coolest' places in Britain. New developments stand alongside the preserved buildings of this erstwhile industrial landscape, housing nightclubs, markets, galleries, eateries and venues. The final part of our tour takes us along Paradise Street, where the sailors found lodgings while they were in port.

start / finish	Merseyside Maritime Museum, Royal Albert Dock
nearest postcode	L3 4AQ
distance	3½ miles / 5.6 km
time	2 hours 30 minutes (excluding museum visit)
terrain	Paved roads and walkways, some uneven or cobbled.

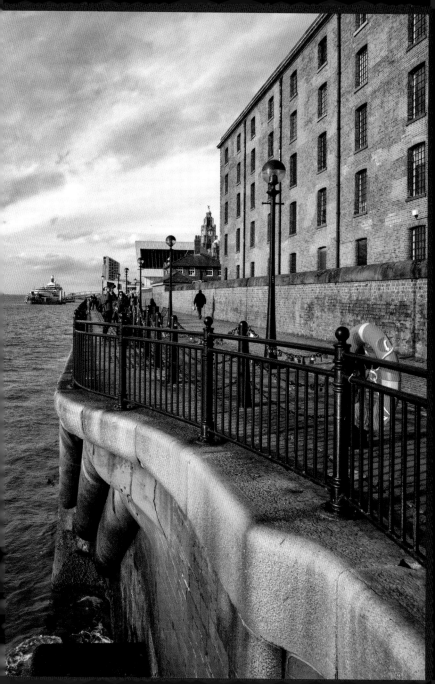

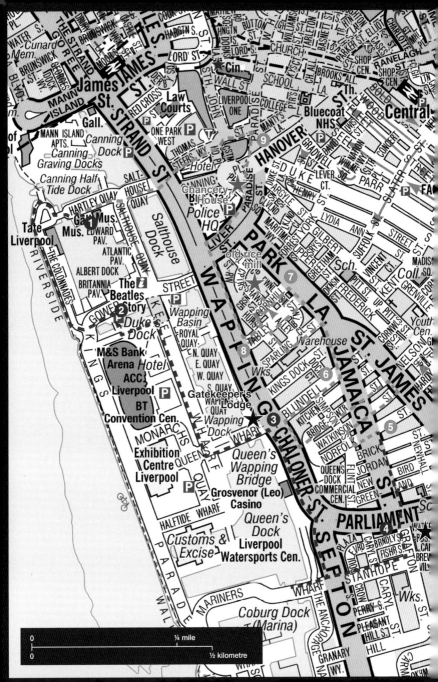

1 From the Maritime Museum (a must-visit, check opening days) at the renovated Royal Albert Dock (1846), you can survey the nearby dock system and cobbled quaysides once busy with dockers, horses and steam engines moving cargoes around. Spot an anchor from HMS *Conwy*, a sailors' training ship. Walk over the inner dock bridge towards the river and the Piermaster's House. The Pier Master's duty was to ensure safe passage of ships into the docks at high tide. Keep left behind the house, passing the *Legacy* sculpture and noting the love padlocks fastened to the chain fence alongside the River Mersey. On your right, across the river, are views of Cammell Laird shipyard. As the wall on your left ends, keep the dock building to your left until you see a pagoda-covered footbridge crossing Duke's Dock (1773). This is the only private dock for barges from the Duke of Bridgewater's Canal.

2 Cross over Duke's Dock then turn left passing the Ferris wheel and turn right onto Keel Wharf. Continue forwards, passing modern hotels and apartments built on the old Kings Dock (1785). The Wapping Dock buildings to the left were built by Albert Dock architect Jesse Hartley in 1855. Spare columns denote a missing section, destroyed in the Second World War Blitz. Turn left at the end of the dock onto Queens Wharf towards the octagonal turreted hydraulic tower and the Gatekeeper's Lodge ★ , an oval structure with a conical roof.

3 Turn right onto Chaloner Street and keep right onto Sefton Street. At the traffic lights, turn right to take a short detour as far as the swing bridge. On your left are views of the Liverpool Marina in Coburg Dock, while on your right is a view of Queen's Dock and the award-winning floating Liverpool Watersports Centre. Return to, and cross over, Sefton Street to The Coburg pub, once known as 'The Devil and the Exciseman'. Continue up Stanhope Street to the magnificent former brewery of Robert Cain which is now a brewery village ★ , with stalls and a lively street food market. Turn left to see the Beatles' Abbey Road album wall mural.

4 Cross Parliament Street onto Jamaica Street then turn right to see the mighty Greenland Street warehouses, housing two schools, apartments and businesses. From 1842 the street was home to the Royal Southern Hospital, established to treat injuries sustained in the nearby South Docks. Return to Jamaica Street passing the skate park carved from a derelict plot. Once an area of abandoned warehouses, Jamaica Street is now at the heart of a vibrant area, with street art, clubs and cafés.

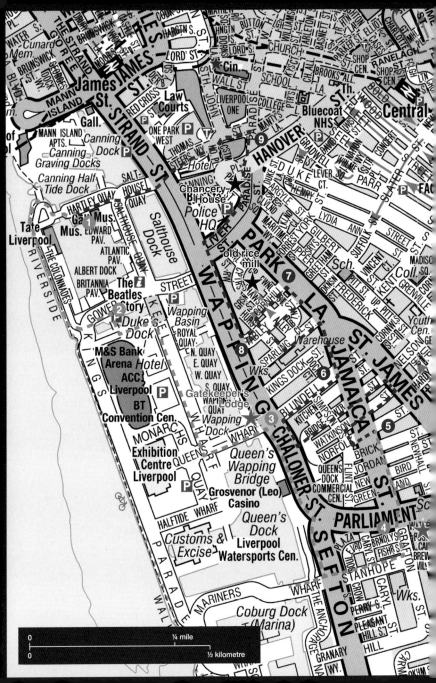

5 Just after the Angel Wings wall mural, turn left onto Norfolk Street, right into Simpson Street then right into Watkinson Street, crossing Jamaica Street to follow this to the end. Turn left onto St James Street and left again onto Bridgewater Street. Pass the new Baltic Hotel, grab a sourdough loaf at the quirky Baltic Bakehouse and maybe quench your thirst at Love Lane Brewery, which occupies a former rubber factory. Queens Store Company building is at the end. Turn right onto Chaloner Street and right into Blundell Street. The warehouses here were among the first to be repurposed as restaurants, clubs and even a theatre. Continue to the junction with Jamaica Street.

6 Turn left onto Park Lane and then left into Sparling Street, with its delightful row of 1930s terraces. Pass the 132 kV substation, turn right along Hurst Street and then right onto Tabley Street. Walk to the end and turn left onto Park Lane. You will see the unusual octagonal Scandinavian Sailors' Church. Gustav Adolfs Kyrka was completed in 1884 to meet the pastoral needs of Scandinavian sailors and emigrants passing through the city to North America.

7 Turn left past the church along Cornhill. From Shaws Alley you can see the old Heaps Rice Mill (1780) ★ . The rice for Kellogg's Rice Krispies was once ground here. Back on Cornhill, the ship-shaped Baltic Fleet pub is at the end. There are secret tunnels leading from the pub's cellars, allegedly used for smuggling and to provide an escape route from the notorious press gangs, who came seeking sailors.

8 Turn right along Wapping. Cross the end of Liver Street and turn right towards Paradise Street, once the heart of sailor town. Pass MerseyMade on the left, occupying part of Chancery House ★ , once the Gordon Smith Institute for Seamen, in Flemish gothic-style red brick. Cross Hanover Street to the ornate green gates marking the site of the former Liverpool Sailors' Home. To the right of these is a rounded building, Church House (1885).

9 Go past the green gates along Paradise Street through the Liverpool One retail and leisure development and follow the curved path around the front of a large department store to see the viewing porthole of Liverpool's Old Dock (1715) which was the first commercial wet dock in the world. (Tours to this are available from the Maritime Museum.) Continue along Thomas Steers Way. To the right are engraved paving stones with the high and low tidal range on the River Mersey. There is a mistake on the Thur 09 entry as the 06 stone next to it has been inserted upside down! Cross The Strand to return to the Maritime Museum.

AZ walk ten

Faith and Hope

Places of worship in the city.

This tour of some of Liverpool's many places of worship is bookended by the two ecclesiastic bastions of the city's skyline: the Roman Catholic and Anglican cathedrals. Both were built during the 20th century and were practically the last religious buildings to be constructed in a city where, historically, many places of worship – some dating from the 1700s – were swept away to allow for Liverpool's burgeoning progress.

That growth attracted people from all over the world who brought a diversity of faiths and established their own places of worship where they could gather in common prayer. Some of these buildings still serve their religious communities while for others, new uses have been found. And for a few, their physical continuance hangs in the balance with only a preservation order in place while they slowly deteriorate. Yet all are part of the city's fabric.

This walk takes us from the Metropolitan Cathedral of Christ the King to Liverpool Cathedral, which are linked by a street named Hope. Passing through Chinatown and around parts of Toxteth provides the opportunity to explore an ethnically diverse neighbourhood that has become home to large numbers of immigrants to the city throughout the last two centuries. Along the way we will pass hidden gems, tranquil gardens, a controversial religious sculpture and an array of architectural styles.

start	Liverpool Metropolitan Cathedral of Christ the King, Mount Pleasant
finish	Liverpool Cathedral, Cathedral Gate
nearest postcode	L3 5TQ
distance	4½ miles / 7 km
time	3 hours
terrain	Paved roads and walkways (some uneven). Rough footpath. Steps and steep gradients.

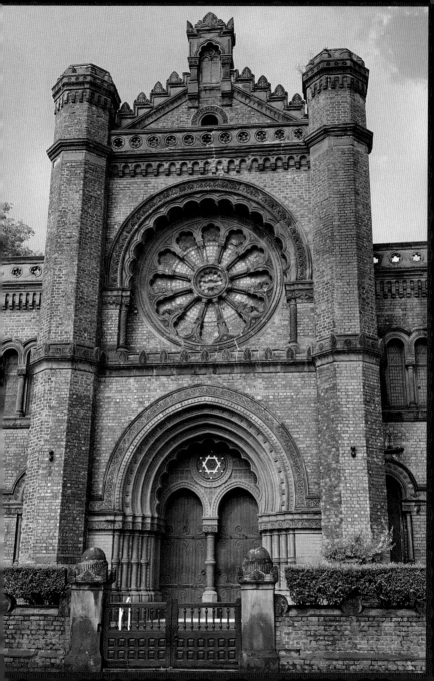

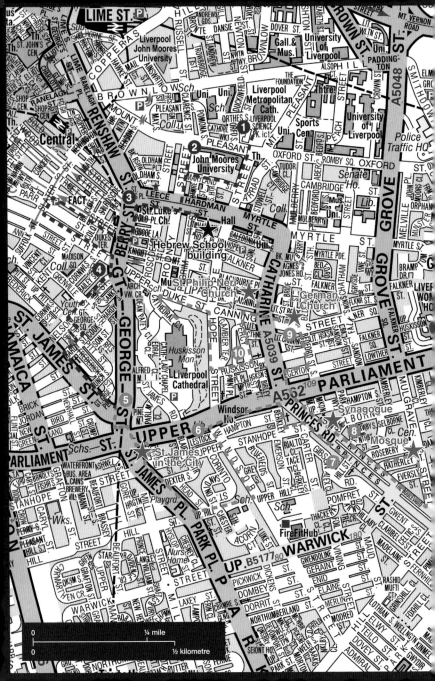

❶ Start at the Metropolitan Cathedral. This was the second attempt to build a Catholic Cathedral in the city after the earlier 1856 building in Everton remained unfinished. Edwin Lutyens intended his design to be the world's second largest cathedral. The foundation stone was laid in 1933, however, work stopped during the Second World War and only the Crypt was completed. Frederick Gibberd's more contemporary design was completed in 1967. Inside, the John Piper stained glass lantern tower throws a magnificent colourwash onto the circular altar. From the front steps, walk straight along Hope Street and turn right at Maryland Street. At Aldham Robarts Library, turn right to explore a hidden garden with a former nunnery chapel. Continue along Maryland Street and turn right onto Rodney Street.

❷ On the right is the former St Andrew's Presbyterian Church (1824), with the supposedly haunted pyramid tomb of former railway contractor William Mackenzie. Turn back along Rodney Street, then left onto Hardman Street, passing a former synagogue (1838) on the right-hand corner. To see its replacement, built in 1857, turn right into Pilgrim Street and continue to Hope Place. The former Hebrew School building ★ is on the corner with, rather oddly, the word 'sanatorium' engraved in the steps. Return to Hardman Street and descend to St Luke's 'Bombed Out' Church (1852), now an arts and events space and Liverpool's monument to the 1941 May Blitz.

❸ Turn left along Berry Street and turn right onto Seel Street. At no. 55 you will see the convent of the Ave Maria Missionaries of Charity. On the opposite side is Liverpool's oldest remaining church, the former St Peter's (1788), now an unusual restaurant retaining many of its original internal features. Continue along Seel Street to Slater Street, turn left, then left onto Duke Street. Walk up the hill to the Chinese Arch and the adjacent domed former Great George Street Congregational Chapel (1841) still known as 'the Blackie' (officially now the Black-E) from the days when it was covered in soot.

❹ Walk through the Chinese Arch, along Nelson Street and turn left at Upper Pitt Street. On the corner with Hardy Street is the Chinese Gospel Church. Turn right along Hardy Street then turn left onto St James Street, passing Vincent De Paul Roman Catholic Church (1857), with its striking gothic open bell tower (bellcote). Continue to the junction with Great George Street, noticing a mural on the side of a former bank, juxtaposing Liverpool Cathedral in the background.

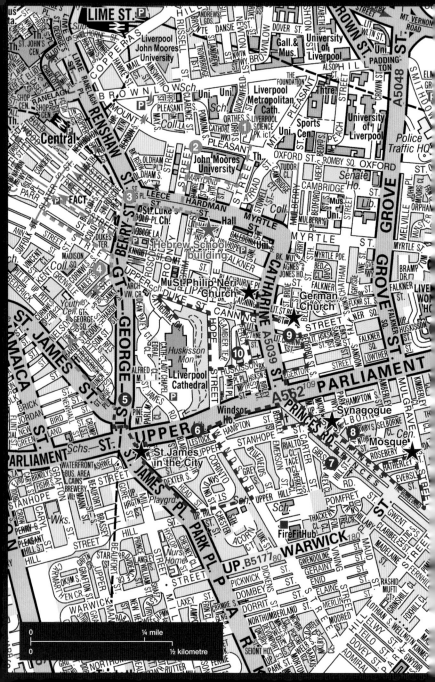

5 At this complicated intersection, keep right and cross the dual carriageway to the elevated church of St James in the City (1775) ★ . Take the left-hand footpath through the grounds. This is an early example of a church with cast iron columns. Continue along St James Place to St Patrick's Church (1821). Turn left before the church and take the alleyway to the left of the primary school. Turn left at the end into Windsor Street, noticing another mural on the side of St James Mission Hall.

6 At the T-junction, turn right and look across Upper Parliament Street to the Church of Saints Peter and Paul (the Society of St Pius X) (1913). Continue to the Rialto building and turn right onto Berkley Street to the Greek Orthodox Church of St Nicholas (1870), which is beautiful inside. At the end of the street, turn left and pass the Kuumba Imani Millennium Centre. Turn right onto Princes Road. Ahead you will see the 200-foot (61-metre) pointed steeple of the disused Welsh Presbyterian Church (1867).

7 Cross Princes Road and continue along Princes Avenue to Mulgrave Street. On the side of Princes Park Methodist Church, the 1969 sculpture, *The Black Christ* by local sculptor Arthur Dooley, caused controversy in its time. Turn left onto Mulgrave Street. The Al-Rahma Mosque (1974) ★ is the main place of worship for Liverpool's Muslim community. Turn left into Hatherley Street, then right onto Princes Avenue.

8 Pass the derelict red brick chapel of the Merseyside Centre for the Deaf (1887) followed by Princes Road Synagogue (1874) ★ , built in a Moorish style and richly decorated inside. Continue past St Margaret of Antioch Church (1869) to the junction of Upper Parliament Street. Cross over onto Catharine Street and turn right into Egerton Street. Turn left onto Bedford Street South and walk to Canning Street. On the opposite corner is the tree-covered German Church (Deutschsprachige Kirche) ★ , which originated from a German prayer meeting on a disused ship on the Mersey.

9 Turn left onto Canning Street, turn right onto Catharine Street and walk to the Byzantine-style St Philip Neri Catholic Church (1920) ★ , with its tranquil Spanish-inspired garden, now the Roman Catholic Chaplaincy to the universities. Retrace your steps along Catharine Street, turn right onto Canning Street, then left into Percy Street and walk to St Bride's Church (1830).

10 Turn right onto Huskisson Street, then right onto Hope Street, and left down Upper Duke Street, passing The Oratory (1829), a former chapel of ease for the cemetery below. Continue to Liverpool Cathedral, the fifth largest cathedral in the world and built between 1904 and 1978. Enter the cathedral beneath the *Risen Christ* sculpture by Elizabeth Frink, affectionately known as 'Frinkenstein', to end your walk.

AZ walk eleven

Two Centuries of Architecture

Georgian, Victorian and Edwardian development
in the city.

This circular walk explores the attractive top end of town once inhabited by
wealthy merchants. Amenities were close at hand for the well-heeled: shops on
Bold Street, private physicians on Rodney Street, churches and private clubs.
Friends, family and business associates might have stayed in the luxurious
Adelphi Hotel, where our walk begins. One of the oldest meeting houses, The
Wellington Rooms had two entrances – one for carriages and one for sedan
chairs. Meanwhile, the poor were hidden away in court housing behind the
finer streets, some attracted to the Victorian gin palaces by the one penny price
tag and the allure of a roaring fire in palatial surroundings. The prosperous were
persuaded to contribute to philanthropic establishments for education, the arts,
health and welfare.

The Georgian (1714–1830), Victorian (1837–1901) and Edwardian (1901–
1910) eras coincided with a long period of tremendous growth in Liverpool,
and evidence of their distinctive architectural styles can be found all over
the city. Cobbled streets survive today along with the remains of Victorian
tramlines and ornate lampposts. At night, the oldest streets appear almost
unchanged.

So, saunter around the streets and squares like a Georgian and perhaps enjoy
a few Victorian pleasures, tea at the Adelphi or even a gin, though now you
would have to pay a few hundred pennies more!

start / finish	Adelphi Hotel, Ranelagh Place
nearest postcode	L3 5UL
distance	3 miles / 5 km
time	1 hour 30 minutes
terrain	Paved roads and walkways (some uneven), cobbled streets, steps and gradients.

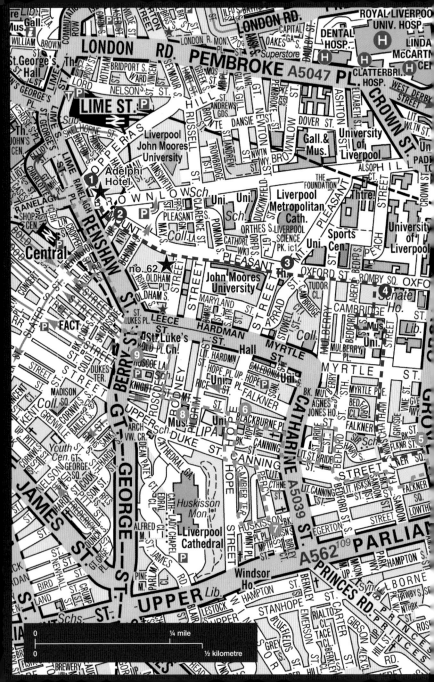

1 The resplendent Adelphi Hotel (1914) ★ is the third building to occupy this site. The original hotel was built in 1826. The current building, developed by the Midland Railway Company, was designed to resemble the grand interiors of ocean-going liners of the Edwardian era. Explore inside and take tea in the Sefton Suite, said to be a replica of the 1st class smoking lounge on the ill-fated *Titanic*. The hotel's opulence attracted the wealthy and famous: Charles Dickens, Laurel and Hardy, Judy Garland, Frank Sinatra, Winston Churchill, Franklin D. Roosevelt. Even local lads, the Beatles, stayed here. To the left of the hotel is The Vines, a former gin palace. On the right is Brownlow Hill; Charles Dickens took the name Mr Brownlow from this road for a character in his novel *Oliver Twist*. Turn up Brownlow Hill.

2 Branch to the right up Mount Pleasant. Walk past the Victorian Beehive pub and then Roscoe Memorial Gardens (the former graveyard of Renshaw Street Chapel). Number 50 is a Georgian house (1780) with an unusual doorway. Next is the red brick Gothic YMCA building (1875). Number 62 ★ is a merchant's house of 1767, making it the oldest house in the street. Number 64 was a register office and 64A a doll's hospital. Number 68 (1788) has cherubs and musical instruments carved above the front door. Further up the hill, a mixture of buildings dating from 1830 are occupied by Liverpool John Moores University. On the left, the Regency former Wellington Club and Assembly Rooms (1815) was once the thriving Irish Centre (from 1965 to 1997). Continue to the junction with Hope Street.

3 On the left, the Metropolitan Cathedral of Christ the King (1967) stands on the site of the UK's largest Victorian workhouse, which closed in 1928. Babies born there had the fictitious address of 144a Brownlow Hill on their birth certificate. The Medical Institution on the corner originated with a group of surgeons starting a medical book club in 1778. Opened in 1837, the building's Medical Library and lecture theatre are still in constant use. Continue along Oxford Street until you reach Abercromby Square.

4 Turn right into the square, passing the central domed summer house to the other side. Liverpool's most affluent families resided here in a palatial garden terrace, along with the Bishop of Liverpool in his 'palace'. The site was acquired for the University of Liverpool in 1924. Turn right, then left onto Bedford Street South, then left again behind the south terrace of Abercromby Square. Take the path past the Garstang Museum of Archaeology. John Garstang founded the Institute of Archaeology in 1904. Turn right onto Chatham Street and continue along Sandon Street then turn left into Falkner Square (1830).

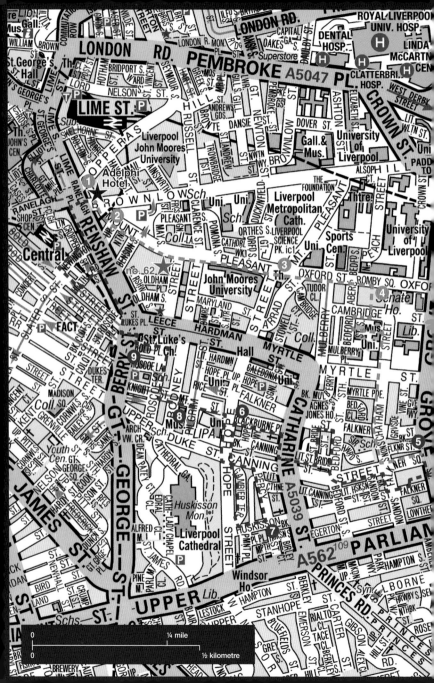

5 Turn right into Grove Street then enter the square through the gate, passing the Black Merchant Seamen War Memorial, to the summer house in the middle. Then, take the left path exiting the square, continuing clockwise around Falkner Square to see a heritage blue plaque at no. 40, the home of pioneering Liverpool architect Peter Ellis. Turn left onto Canning Street, right at Bedford Street, left at Falkner Street and left into the attractive St Bride Street, often used as a filming location. At the street's end, turn right, then right onto Catharine Street and left down Blackburne Place.

6 At the end of the road, on the right, is Blackburne House (1788), built for prosperous salt importer and enslaver John Blackburne. Turn left into Hope Street. With a view of Liverpool Cathedral, cross Canning Street to the driveway of Gambier Terrace, built in the 1830s for its views across the River Mersey to North Wales. At the end of the terrace, turn left onto Huskisson Street, then left onto Percy Street.

7 The neo-classical St Bride's Church (1830) offers services of faith and food to the community. At the end of Percy Street, turn left and then right onto Hope Street. Turn left down Mount Street at *A Case History* sculpture. Pass the former art college and Liverpool Institute for Boys (1832), now combined as the Liverpool Institute for Performing Arts (LIPA).

8 At the junction of Pilgrim Street you will see The Pilgrim pub, with its subterranean saloon with vaulted ceilings. This has formerly been a warehouse, a shebeen (unofficial house selling liquor), a paint store and a chocolate factory. Continue your descent onto Knight Street and turn right at The Grapes pub onto Roscoe Street. Turn left onto Bold Place to see St Luke's Church (1832), which was bombed in the 1941 Blitz, however, it continues as an open-air arts and events space.

9 Turn right into Renshaw Street and turn left at Heathfield Street, cutting through to Bold Street and turning right. The historic feel of the street is still palpable, full of independent establishments. Take the next right onto Newington. At the junction with Cropper Street, you will see an early Victorian warehouse, part of Newington Buildings. From the street, you can appreciate the magnificent Art Nouveau, Grade II listed Grand Central Hall (1905), a former Wesleyan Methodist Mission Hall also once home to the New Century Cinema. Turn left along Renshaw Street and return to the Adelphi where the walk is complete.

∀Z walk twelve

The Knowledge Quarter

The history and architecture of health and education.

Nineteenth-century Liverpool was at the forefront of medical innovation. It had the first Medical Officer of Health appointed in a British city, the world's first tropical medicine school dedicated to research and teaching, a prominent bone setter and a pioneering radiologist. With so many specialist hospitals, Liverpool had the consultant physicians of a capital city, and still has.

The Universities, too, have their proud beginnings, in fine establishments that have expanded to envelop many buildings around the city which otherwise might have fallen derelict or been reimagined by property developers. Today, the city's higher education sector is booming, with around 60,000 students on campus at three universities (University of Liverpool, Liverpool John Moores and Liverpool Hope) alone.

This circular walk provides a glimpse into Liverpool's medical and educational history while exploring the area to the east of the city centre. The route takes in old hospitals, new hospitals, halls of residence, colleges and head offices. We'll see old institutes and red brick towers, and a delightful university square in which to read for hours.

To gain the most from this walk, it is best done during office hours (Monday to Friday), when certain University buildings and entrances are accessible to the public.

start / finish	Junction of Berry Street and Seel Street
nearest postcode	L1 4BL
distance	4 miles / 6.5 km
time	2 hours 30 minutes
terrain	Paved roads and walkways (some uneven). Steps (optional).

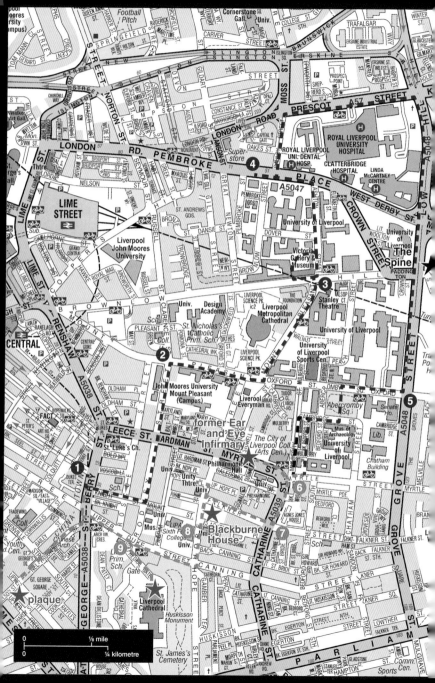

1 Outside the Blue Angel Club, near the top of Seel Street at no. 106–108, is a blue plaque marking the birthplace of Dr William Henry Duncan. He was the UK's first Medical Officer, appointed in response to the Liverpool Sanitary Act of 1846 to alleviate the city's poor health record by improving sanitation. At the junction of Seel Street and Berry Street, turn right, then cross over and walk up Knight Street. Turn left at Rodney Street, where there are several private medical clinics. At no. 43 there is a plaque to Charles Thurston Holland, a pioneer of radiology. Continue across Hardman Street to the end of Rodney Street.

2 Turn right onto Mount Pleasant. The university buildings immediately to your right once housed the Royal Infirmary and part of the School of Dentistry. The world's first district nursing service started here in 1862. At Hope Street's corner, the classical curved building with a domed skylight was the original Medical Institution (1837) and library and is still used today for medical lectures. Keep left following Mount Pleasant alongside the Metropolitan Cathedral, once the site of the largest workhouse in Europe. To the right is the University of Liverpool campus. The old Guild of Students building (1911) was designed by Sir Charles Herbert Reilly, who headed the School of Architecture.

3 Facing the junction with Brownlow Hill you will see the impressive red brick Gothic original university building (1889) built by Alfred Waterhouse. If open, do take the time to appreciate the vaulted glazed tiled interior and the exhibits in the Victoria Gallery and Museum. Either walk through to the quadrangle via the gated archway on the left of the building and turn left into Ashton Street, or walk straight up Ashton Street through the pedestrianized campus. At the end, turn left onto Pembroke Place. Pass the old Liverpool Royal Infirmary, next door to which is the Liverpool School of Tropical Medicine, a world pioneer in research.

4 Turn back briefly along Pembroke Place, where you are immediately faced with the view of the new Liverpool Hospital (2022), and then left along Daulby Street. At the end, turn right into Prescot Street. On your right are the 1970s hospital buildings. Bear right onto Low Hill towards a tall blue/green giraffe-print building called The Spine (2021) ★ , its name from an interior staircase that resembles human vertebrae. This is the headquarters of the Royal College of Physicians.

5 Turning right at Oxford Street, you will see the University of Liverpool's new Tung Music Auditorium and Yoko Ono Lennon Centre. Turn left to walk through the Georgian Abercromby Square, turning right out of the gardens. At the end of Cambridge Street, spot The Cambridge pub (the lecturers' haunt). Turn left into the alleyway before the pub via the University Music School, or continue to the pub and turn left onto Mulberry Street.

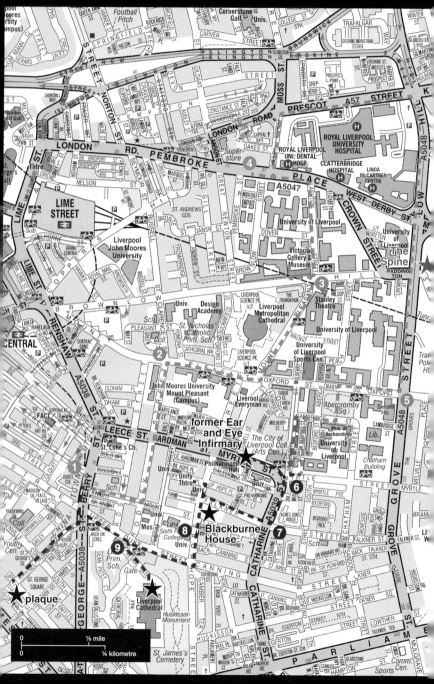

6 Turn right on Myrtle Street past The City of Liverpool College, which occupies the site of the former Royal Children's Hospital, built in 1881. Further along is the red brick former Ear and Eye Infirmary building (1879) ★ with its inscriptions and carvings of biblical parables. Turn back and bear right onto Catharine Street. Pass Agnes Jones House, set back on the left, the former Women's Hospital and now a student hall. Agnes Jones trained under Florence Nightingale and in 1865 was appointed the first Nurse Superintendent of the Liverpool Workhouse infirmary.

7 Turn right onto the cobbled Falkner Street. Facing the end of the street is an early homeopathic medical centre, the Hahnemann Hospital (1887), with its large windows to let in light and air. Take a short diversion across Hope Street to the right side of the hospital on Hope Place to see the old doorway of the Dispensary. Returning to Hope Street, opposite the suitcase sculptures is Blackburne House ★ . Originally a private house (1788), it was later remodelled as a girls' school and college (1876). Looking down Mount Street, the classical building with columns is the former Mechanics' Institution (1832). It later became the Liverpool Institute for Boys (attended by Paul McCartney and George Harrison). The corner building is the former Liverpool College of Art (1910), where John Lennon studied.

8 Continue along Hope Street until on your right is the cathedral and diagonally left is Gambier Terrace. Number 9 was the city's first family planning clinic, the Mothers' Welfare Clinic, pioneering trials of the contraceptive pill in the 1960s. Turn right onto Upper Duke Street and descend to Liverpool Cathedral ★ . Inside, on the Lady Chapel staircase, two windows commemorate 'noble women' Agnes Jones and Kitty Wilkinson, an Irish widow who took in washing from cholera sufferers and set up bath and wash houses in the city.

9 Return to Duke Street and descend to the junction with Berry Street. Turn left to Chinatown's Chinese Arch, in what was an early residential area of the city. Walk through the arch and along Nelson Street. After the junction with Upper Pitt Street, look out for the rectangular plaque ★ on the building on the left. This marks the site of 11 Nelson Street, from 1866 the consulting rooms of Welsh bone setter Hugh Owen Thomas. Together with his nephew, Robert Jones, the two became known as the fathers of modern orthopaedics. Jones, a notable surgeon, worked with Rodney Street colleague Charles Thurston Holland to use X-rays to diagnose fractures. Return to the Chinese Arch and cross back onto Berry Street to complete the walk.

AZ walk thirteen

Stanley Dock and Stanley Park

The canal, football stadia and Everton Brow.

The 127-mile-long Leeds & Liverpool Canal was completed in 1816 to connect the port with the industrial and coalmining areas of Lancashire and Yorkshire. The canal link through the Pier Head into the Royal Albert Dock was reinstated in 2009, but for this walk we will start at the former Stanley Dock tobacco warehouse, which is connected to the canal by a flight of locks. It is also close to Bramley Moore Dock, the site of Everton Football Club's new stadium, which we will visit as well as its historical home, the 'Grand Old Lady' of Goodison Park, and Liverpool Football Club's stadium at Anfield. Both clubs have long histories, and we will see their stadia still in the heart of residential communities using different solutions to increase capacity for their many loyal local and overseas supporters.

On this circular walk, we pass through neighbourhoods steeped in industrial history and urban tales. Scotland 'Scottie' Road, where the port's dockers lived, became an overcrowded slum following the mass immigration from Ireland during the mid-1800s, and although the slums are now largely cleared, evidence remains of the area's colourful past.

There is also a stunning Arts and Crafts housing estate, but the highlight of the walk is the breath-taking view over the city from Everton Brow. It's a great walk for a picnic, or there are plenty of places to buy refreshments, including a wonderful Victorian glasshouse.

start / finish	Titanic Hotel, Stanley Dock, Regent Road
nearest postcode	L3 0AN
distance	6 miles / 9.5 km
time	3 hours
terrain	Canal towpath, paved roads, surfaced paths, steps and some inclines.

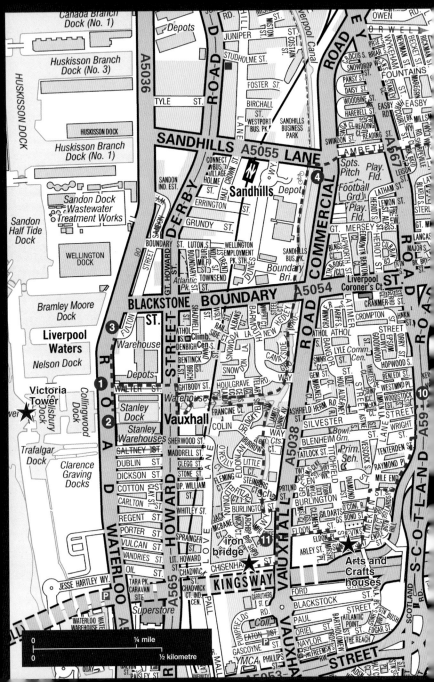

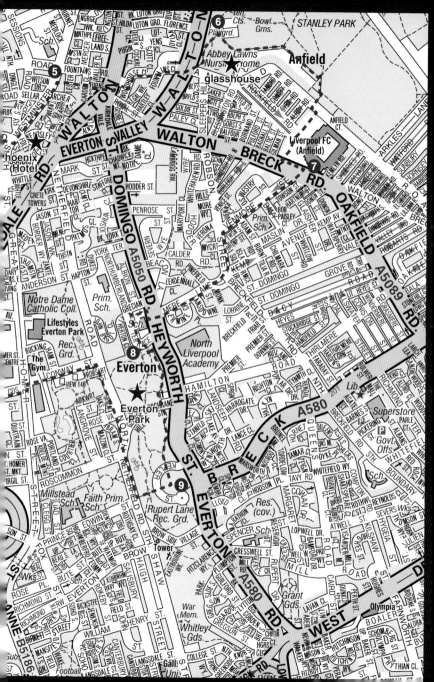

1 Start at the entrance to the Titanic Hotel, part of the Stanley Dock complex. Turn left along Regent Road to see a restored bascule bridge (*bascule* is the French word for seesaw). The enormous Stanley Tobacco Warehouse (1900) was the world's largest brick warehouse, with a capacity of 1.6 million square feet (0.15 square kilometres). Note a small gap in the wall at the far end of the dock, which is the access to the dock system from the Leeds & Liverpool Canal. This site has a new use as a film location, for productions including *Sherlock Holmes*, *Captain America* and *Peaky Blinders*.

2 Turn back along Regent Road, stopping to look across Collingwood and Salisbury Docks to the wonderful Victoria Tower ★ , or 'Dockers' Clock'. Follow the dock wall to Bramley Moore Dock, the new home of Everton Football Club. This stadium has a 53,000-seat capacity, its construction set to cement the regeneration of the Northern Docks. You will see the redundant iron supports for the Overhead Railway which closed in 1956. When it rained the dockworkers used to shelter underneath and it is still remembered locally as the 'Docker's Umbrella'.

3 Double back along Regent Road and turn left onto Walter Street. At the top, keep to your right as you cross Great Howard Street looking for a gap in the wall and a brass plaque marking the entrance to the Leeds & Liverpool Canal. Follow the canal path, keeping to the left, to the top of the flight of locks. Follow the towpath round to the left and continue for half a mile (800 metres) to the Sandhills Bridge.

4 Climb to the road and turn right over the bridge, crossing Commercial Road at the junction to continue up Lambeth Road to the end. Turn left onto Westminster Road. The Phoenix Hotel ★ to the right is around 160 years old and once claimed to have the longest bar in Liverpool. It was converted to a nineteen-bed hotel in 2020 and at the same time the Beatles mural was commissioned.

5 Just after Witsun Drive, turn right onto a path alongside St Mary's Cemetery which leads onto Furness Street. Cross Walton Road and turn left then right to cut through Woodhouse Close and Fountains Close. Cross Walton Lane into Stanley Park, which opened in 1870. Once in the park you will see the Victorian glasshouse ★ , now a lovely café. Looking across the park to your left from the conservatory is the ground where Everton Football Club began playing in 1892. Everton play in blue and are known locally as 'the Blues' or 'the Toffees'. The Toffees name originates from a time when a local sweet shop owner started throwing Everton Mints, a black-and-white-striped sweet, into the crowds. This tradition continues to this day.

6 Keeping to the right-hand path of Stanley Park, make your way to Anfield Road, dominated by the 61,000-seat stadium of Liverpool Football Club. As you leave the park, cross Anfield Road. Keep the stadium to your left and the houses on your right. Alongside the stadium is the Hillsborough Memorial remembering the ninety-seven people who lost their lives during the disaster at the 1989 FA Cup semi-final in Sheffield. Continue along 97-Avenue, passing the Museum and Stadium Tour entrance and the Official Merchandise Store. Walk around to the front of the stadium to the statue of Bill Shankly, Liverpool's former manager.

7 Cross Walton Breck Road opposite the statue and walk down Venmore Street, turning left at the end onto Robson Street and then right along Mere Lane. At the end, turn right onto Heyworth Street. Walk through the grounds of St Georges 'Iron' Church and turn left onto Northumberland Terrace. After the road bends to the left, enter Everton Park ★ on your right.

8 Take the left path and stay parallel to Heyworth Street, passing the former Cochrane Street Chapel and the children's playground. Continue to Everton Ridge, 245 feet (75 metres) above the city. Take in the views across the River Mersey to the Wirral Peninsula, the windfarm in Liverpool Bay and the huge red cranes at the Port of Liverpool. On a clear day you can see as far as Snowdonia.

9 From the viewpoint, take the middle path and the steps straight down, and turn right onto Netherfield Road South, which becomes Netherfield Road North. Turn left onto Conway Street. Continue to Great Homer Street, cross over and turn left then right into Chapel Gardens, passing St Anthony's Catholic Church (1833) to Scotland Road.

10 Cross Scotland Road at the traffic lights and turn left onto a footpath, keeping the railings on your left until you reach Burlington Street. Turn right here and then left onto Limekiln Lane. Pass Liverpool's last remaining original-style tenements at Eldon Grove and continue round the bend to the Arts and Crafts houses ★ at Summer Seat (1911). Turn right into Titchfield Street and left down Eldon Place. Take the path between the houses on the right and go left at the end, passing the Church of Our Lady of Reconciliation built by Edward Pugin in 1860, to the end of Eldon Street.

11 Turn left onto Vauxhall Road then right onto Chisenhale Street to see the wrought iron bridge ★ that used to cross the canal. Historically, this area was a short cut from the docks and known for tales of murder and muggings. Double back along Chisenhale Street and Vauxhall Road and turn left onto Burlington Street. Turn right after the octagonal village hall to join the canal towpath and turn left back down the flight of locks to return to the start.

⒜⒵ walk fourteen

Larks in the Parks

St Michael's Hamlet, Sefton Park and Lark Lane.

This circular walk starts at St Michael's Hamlet and explores the area that was once a medieval royal hunting forest and is now an affluent suburb to the southeast of the city centre.

We will see an almost forgotten ancient chapel before visiting Princes Park, designed by Joseph Paxton in 1842 and setting the style for urban parks across the country which were created to provide green and tranquil havens in the overcrowded Victorian cities. We progress to Sefton Park, a magnificent Grade I historic park where tree-lined avenues escort us to the botanical splendour of the Palm House and to the boating lake.

You can visit a third park by taking the optional extension to Greenbank Park, with its walled garden laid out to an old English design (check opening times), before returning through Sefton Park. Our walk ends with a stroll along vibrant and bohemian Lark Lane ('the lane' to the locals), where you have the opportunity to refuel in one of the cafés or bars and browse around the independent shops.

There is a regular train service between Liverpool Central/Moorfields and St Michael's.

start / finish	St Michael's Railway Station, Southwood Road
nearest postcode	L17 7BG
distance	5¼ miles / 8.5 km (6½ miles / 10.5 km with optional extension)
time	2 hours 30 minutes (3 hours 15 minutes with optional extension)
terrain	Pavements, rough pathways, steps.

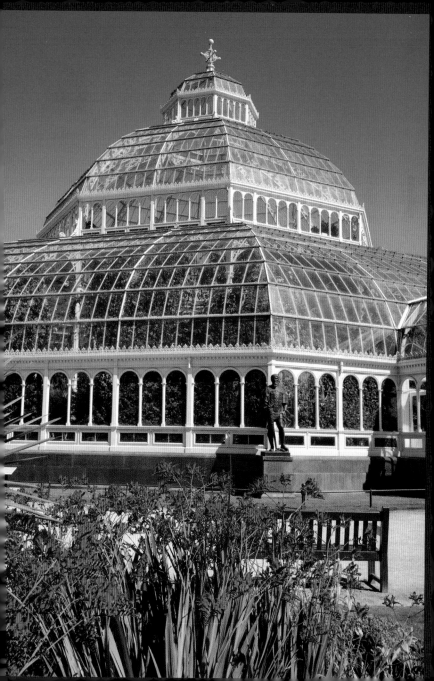

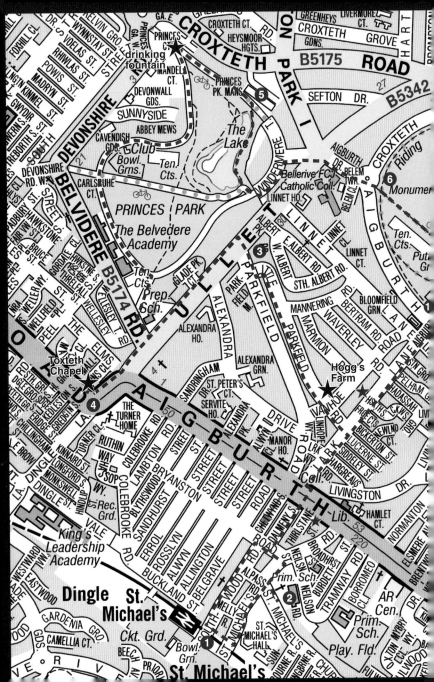

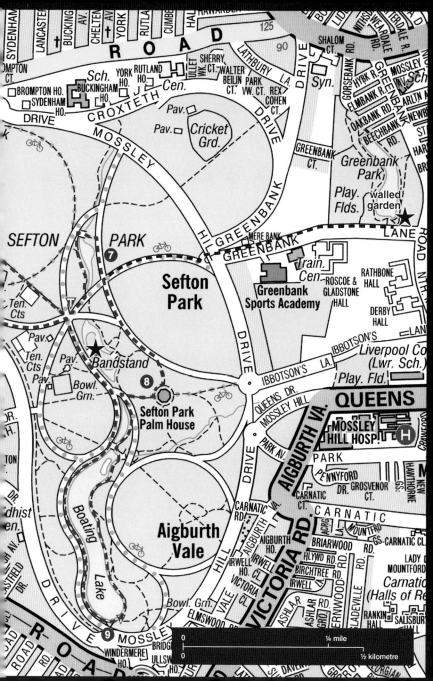

1 With the station building to your back, take the gap in the wall opposite, up the steps and onto the path. At the end, turn left onto St Michael's Road. Opposite Melly Road, the large white house with an iron porch and iron window frames is a Grade II listed building called The Cloisters (1815), built by John Cragg, the owner of the Mersey Iron Foundry. Turn right into St Michael's Church Road to the iron-framed church of St Michael in the Hamlet (1815), built by Cragg to the design of architect John Rickman. St Michael's was designated a conservation area in 1968 and there are more John Cragg buildings within the Hamlet, including the two houses either side of the road immediately past the church on St Michael's Church Road. The one on the right, set back from the road, is The Hermitage (1815).

2 Return to, and continue along, St Michael's Road. On your right is Cragg's own home, a large white house called Hollybank with an iron door canopy, iron window frames, large stables and a coach house. Turn left onto Bryanston Road and right onto Dalmeny Street and cross Aigburth Road to Lark Lane (which you will have the opportunity to explore at the end of the walk). Continue until Little Parkfield Road and turn left. Number 1A is now a delicatessen but was previously the Hogg family dairy. Further along, at no. 3, notice a green garage with 'Wm Hogg Parkfield Farm' ★ on the door, where cows and pigs were kept from 1881 (pigs until as recently as 2000). Each day the cows would be herded along Bryanston Road to graze on the pasture by the river. Continue to the junction with Parkfield Road.

3 Turn right, cross over Ullet Road and turn left. Cross over Belvidere Road and turn right into Park Road to see the 400-year-old Ancient Chapel of Toxteth ★. Oliver Cromwell's troops are said to have camped in the churchyard in 1644 during the English Civil War. It also houses the grave of Toxteth-born astronomer, Jeremiah Horrocks, who was the first to observe the transit of Venus in 1639.

4 Return along Ullet Road and turn left onto Belvidere Road. On the right, just past the school, enter the gates of Princes Park, which was designed by Joseph Paxton in 1842. Follow the left-hand path some distance to the needle obelisk drinking fountain (1858) ★ close to the sunburst gates. Go clockwise around the obelisk, staying to the left on the wider surfaced path behind the Victorian villas and a Georgian terrace until you see the tip of the lake on your right.

5 Leave the main path. Keep the lake on your right-hand side and follow the path until you see the metal gates on the left. Leave the park via Windermere Terrace. After passing three large houses, turn right and walk to the traffic lights where you will see the Ullet Road park gates across the junction. Enter Aigburth Drive between the impressive

granite pillars, which were salvaged from St George's Hall in the city centre when the columns were removed to install a new pipe organ. Pass the gatekeeper's lodge, cross a small roundabout and enter Sefton Park.

6 The park was designed by Edouard Andre and Lewis Hornblower in 1872. From the obelisk monument, follow the tree-lined gravel path past the tennis courts on the right to the Shaftesbury Memorial Fountain (1932) which is a replica of the 'Eros' fountain in Piccadilly Circus in London. Turn left alongside the café then immediately left and walk through the former aviary. Turn left, back onto the path following the stream, which you either cross to your right on the stones above the cascade or, further on, on the path. Make a U-turn and continue with the stream on your right until you reach a crossroads of paths.

7 At this point, you could extend your walk to visit the walled gardens ★ and café at Greenbank Park by turning left here and exiting the park, then continuing on Greenbank Lane, the right-hand road of the two roads facing you across Mossley Hill Drive. Greenbank Park is at the top of the road on the left. Afterwards, retrace your steps to the crossroads of paths and turn left. Otherwise, continue straight over the crossroads of paths. Keep the huge open park space to your left until you see the Grade II listed Palm House (1896), built by Scottish ironworkers, MacKenzie and Moncur.

8 Facing the main gates of the Palm House, walk anticlockwise for 45 degrees around the Palm House then turn right down some steps and then left, with the stream on your right. You are now going to do a clockwise circuit of the boating lake, passing an unusual-shaped glass café with toilets. Behind the café, alongside the road, you can see the lodge and the gates at the southern entrance of the park, and another decorative drinking fountain.

9 Continue around the lake, eventually passing a rock bridge. As the lake narrows, keep to the left, passing an ornate Chinese-themed bandstand ★ on its own island. Continue to the Eros fountain then take the second turning on the left to pass the Mersey Bowmen tennis courts and the children's play area.

10 Leave the park and cross Aigburth Drive into Lark Lane Conservation Area, with its independent shops and cafés. Pass the old police station on the left, now a community centre. Buildings of interest include The Albert on the left and the attractive Maranto's on the right. Once you reach the junction of Little Parkfield Road, retrace your steps across Aigburth Road and along Dalmeny Street. For a shorter route back to St Michael's station, turn right at the end of Dalmeny Street and immediately left onto Southwood Road.

∆Z walk fifteen

Places to Remember

Wavertree and Penny Lane.

The song 'In My Life' by John Lennon was specifically about his daily bus journey from his home, called 'Mendips', to Liverpool College of Art. John would wait at the bus shelter at the end of Penny Lane for his friends – including George Harrison and Paul McCartney – on the way to their schools and colleges in the city centre.

The three members of the Beatles spent childhood years in Liverpool's southeastern suburbs, which we will explore on this circular walk. The old township of Wavertree was mentioned in the Domesday Book, and although it was swallowed up into the Liverpool conurbation long ago, it retains centuries-old features that give clues to its history.

As well as visiting places associated with the three Beatles members, we will also see a 15th-century well, a quirky Georgian lock up, a Victorian clock tower and (possibly) England's smallest house. Along the route we will pass several green heritage plaques at key locations, installed by a local conservation group called the Wavertree Society.

There is a regular bus service between the city centre and the Plattsville Road bus stop on Allerton Road, where the walk starts and finishes.

start / finish	Plattsville Road bus stop on Allerton Road, Mossley Hill
nearest postcode	L18 1LG
distance	2¾ miles / 4.6 km
time	2 hours
terrain	Pavements. One long, slight incline.

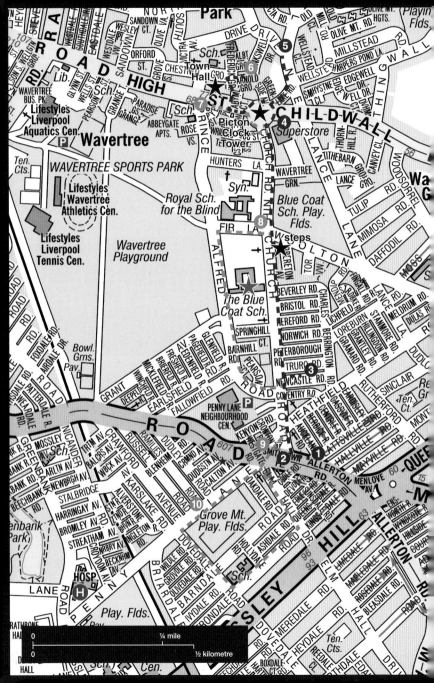

1 As you face the road from the bus stop, turn right along Allerton Road. Ahead you will see 'the shelter in the middle of a roundabout' that Paul McCartney and John Lennon wrote about in the 1967 song 'Penny Lane', formerly an Art Deco bus and tram terminus. Before you reach the shelter, you will pass the bank on the corner where, according to the song, 'the banker never wears a mac [*a mackintosh or raincoat*] in the pouring rain, very strange!'.

2 Turn right here onto Church Road. The shop next to the bank was formerly Albert Marrion's photographic studio, where promotional photos were taken for the Beatles' autograph cards. Continue up the road to Newcastle Road on the right. John Lennon lived here with his mother Julia Lennon (née Stanley) until he was 5 years old. John explained why his favourite number was 9 by saying: 'I lived in 9 Newcastle Road. I was born on the 9th of October. It's just a number that follows me around.' The house was valued in 2013 at £175,000 then sold anonymously in an auction at the Cavern Club for £480,000!

3 Return to Church Road and continue along it, passing the Bluecoat School where John Lennon's father Alfred (Freddie) Lennon was a pupil. Opposite Holy Trinity Church is a set of old sandstone steps ★ that was used to mount horses. Continue to the top of the road, to the former Abbey Cinema

where John Lennon watched matinees. This Art Deco building opened in 1939. Opposite the cinema is the Renaissance-style Picton Clock Tower (1884) ★ , designed by local architect, James Picton, in memory of his wife Sarah Pooley.

4 Cross Childwall Road at the zebra crossing and continue along Lake Road. On your right is an octagonal brick building, constructed in 1796 to lock up drunks and to isolate cholera victims. Turn left onto Mill Lane and as you pass the children's playground, look out for the small merestone engraved with a large letter 'S'. This would have marked the boundary of the land owned by the Marquess of Salisbury. Just after the playground is the 15th-century Monks Well.

5 Retrace your steps to the Picton Clock Tower and on to Wavertree High Street. Just past Waterloo Street, on the left-hand side of the road, is Liverpool's only surviving example of a Georgian bow-windowed shopfront, now a wood turner's workshop. Turn right up the lane just after Abbey Mill Court then right into Arnold Grove. George Harrison was born at no. 12 on 25 February 1943. George, who was the youngest of four children, said of the house: 'The front room was never used. It had posh lino and a three-piece suite, was freezing cold and no one ever went in it.'

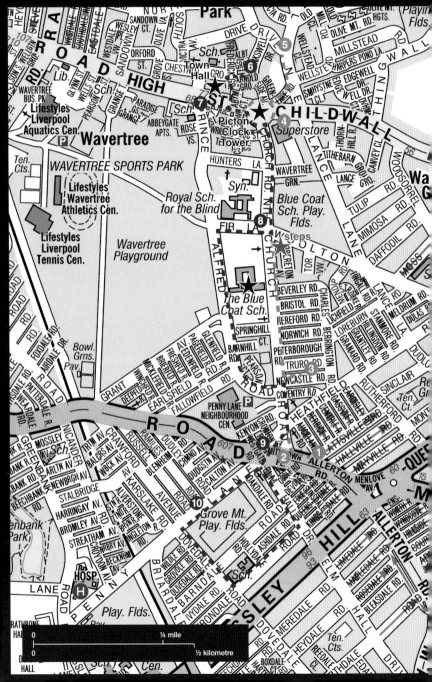

6 Retrace your steps to the High Street and turn right to see a tiny house immediately before The Cock and Bottle pub. This 19th-century dwelling is 6 feet (1.8 metres) wide and 14 feet (4.3 metres) long and is possibly England's smallest house. As many as eight children once lived here, their father having to go up the stairs sideways due to his shape! Carry on down the High Street to Wavertree Town Hall (1872) ★. George Harrison's birth was registered here and in 1957 John Lennon and Paul McCartney played here as the Quarrymen.

7 Return to the Picton Clock Tower and turn right, back down Church Road North, then right into Waterloo Street just before The Coffee House pub. Forming part of the wall on the right are the remains of an 18th-century sandstone cottage, with bricked-up windows and a doorway. Return to Church Road North. You will pass the gates of the former Wavertree Hall, permanently locked by the Squire 200 years ago after his daughter eloped in disgrace with the coachman! The gates now form part of the Royal School for the Blind, which opened in 1898.

8 Turn right onto Fir Lane, passing the cemetery, then left onto Prince Alfred Road, with a large park on the right. No one is sure how this green space got its name, though it could allude to an unsolved murder, hence it is known locally as 'The Mystery'. Continue to the end of Prince Alfred Road and turn

right, back onto and Church Road to Tony Slavin's barber shop, the Penny Lane barbers formerly owned by the Bioletti family. The Beatles had their hair cut here and more recently it was visited by Paul McCartney with James Corden in a 'Carpool Karaoke' TV episode.

9 Cross Smithdown Road to St Barnabas Church, where Paul McCartney used to sing in the choir. Walk down Penny Lane to the Penny Lane Development Centre, which has the original doors from the fire station mentioned in the song: 'when the fireman rushes in'. There is a souvenir shop with photographs of John Lennon taken on 6 July 1957, the day that he was introduced to Paul McCartney. In the gardens is a Beatles mural and the mini yellow submarine used to promote the Beatles' film.

10 Continue along Penny Lane and pass Dovedale Towers, a former guest house where Freddie Mercury once stayed. John and Paul also played at 'the Dovey' with the Quarrymen in 1957. Turn left onto Dovedale Road and left at Herondale Road. At the school entrance there is a plaque remembering John Lennon's attendance at Dovedale Infant School from May 1946 to July 1948. Continue to the top of Herondale Road and turn left onto Elm Hall Drive to return to the bus stop on Allerton Road.

AZ walk sixteen

The Earls' Seat

West Derby and Croxteth Country Park.

Meaning 'place of the deer', West Derby is said to have been established a thousand years ago by Edward the Confessor. The township was once an important administrative centre in the northwest of England, with both a castle and a courthouse. The powerful Molyneux family, later Earls of Sefton, had their family seat at Croxteth Hall from about 1710 until the last earl died in 1972.

As Liverpool expanded, West Derby became a sought-after suburb. Wealthy merchants built substantial mansions which we will pass on the walk. As early as 1830, Charles William Molyneux, the 3rd Earl of Sefton, acquired land from Lord Salisbury to redesign the village. The work was completed in 1856 by his son William Philip Molyneux, the 4th Earl, with the new St Mary's Church and village buildings complementing the main entrance to his estate.

This circular walk takes us through the charming village centre and into Croxteth Country Park, the former hunting chase of the Molyneux family. On the death of the 7th Earl, this was bequeathed to the people of Liverpool in 1972 and is now managed as a public park. We will also view the magnificent hall itself, which can be visited at the end of the walk, when open.

There is a regular bus service between the city centre and Croxteth Country Park, and limited free parking within the park itself (check opening times).

start / finish	Croxteth Country Park car park, Oak Lane/ Muirhead Ave East
nearest postcode	L11 1EH
distance	6 miles / 9.75 km
time	3 hours
terrain	Paved roads and walkways, surfaced footpaths.

❶ Starting at Croxteth Hall car park, walk back up the drive to the roundabout. Turn left onto Muirhead Avenue East. Pass Larkhill Hall then turn left onto Meadow Lane, walking alongside the low sandstone wall of Lord Sefton's estate. Just before the village, on the right, is a green open space, the former site of a medieval motte and bailey castle. Next to this is St Mary's Primary School, with its Victorian tower. The surrounding roads (Castleview, The Armoury and Castle Keep) are all clues to the site's history. In front of The Hunting Lodge pub is a gothic monument (1870), on the site of altar of the old West Derby Chapel. The monument was designed by Eden Nesfield, who also designed the cottages (1861–7) in front of St Mary's Church. The bell and sundial from the chapel are now in the school on Meadow Lane. Opposite this is the single-storey Manor Court House (1662) which is open most Sunday afternoons from April to October.

❷ On the right-hand corner of Meadow Lane are metal stocks, last used during the 1860s. Turn right and pass the sandstone 'Yeoman's House' from the 1580s. Cross the road and continue to Almonds Green, passing the former West Derby Picture House (1927), whose exterior has been recreated. At Haymans Green turn left and walk to Lowlands (1846), a Grade II listed villa now a community centre and West Derby Society headquarters. During the 1960s the basement

became the Pillar Club, hosting bands including John Lennon and Paul McCartney as the Quarrymen.

❸ Turning left, walk to no. 8 Haymans Green, the Casbah Coffee Club ★. In 1959, Mona Best (mother of the Beatles' original drummer Pete Best), opened the cellars of her home as a coffee bar. John Lennon and his band the Quarrymen helped decorate the basement and were the resident band. The club was a huge success featuring many local bands. Rather fittingly, the Beatles played the club's last ever gig in 1962. Private tours can be arranged. Continue along Haymans Green then turn right onto Mill Lane.

❹ Immediately after the playing fields on your left is the former West Derby Railway Station (1879) ★. The railway line beneath the road closed in 1960 and is now a cycle path. The royal train stopped here in 1874, bringing guests to stay with Lord Sefton at Croxteth Hall. Continue to the traffic lights and turn left onto Queens Drive.

❺ Take the third turning on the left into North Drive, through the gates into the private residential Sandfield Park, an exclusive area built for the wealthy in the 1850s. Only a few of the villas remain, but the names survive. Turn right and follow the circuitous South Drive to the end, through more gateposts.

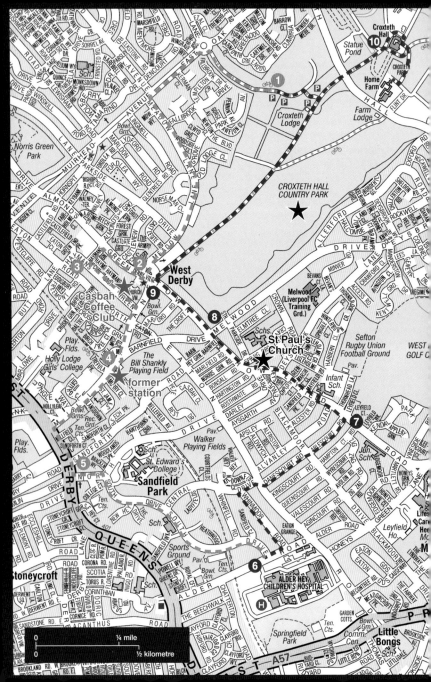

6 Turn left onto Alder Road, passing the tiny Grade II listed lodge of demolished Alder Hey House, the site now occupied by the hospital bearing its name, which opened in 1914 for both children and First World War patients. Turn left onto Whinmoor Road. At the end, turn right along Central Drive. On the left is Grade II listed mansion Alder Grange, previously known as Kiln Hey. Edward Hatton Cookson, a wealthy shipping merchant and former Lord Mayor of Liverpool, lived here in the early 1900s. Cross Eaton Road, turning right then left onto Danescourt Road. Cross Blackmoor Drive and continue along Arlescourt Road.

7 Turn left at the end onto Leyfield Road. You will see a curious red brick lodge on the left and then a cottage dating from the 1700s on the right. Pass the Royal Standard pub (early 1860s) then follow Town Row to St Paul's Catholic Church (1915) ★ on the right and take the path through the churchyard to Spring Grove. Turn left to return to Town Row and continue right, cross Melwood Drive.

8 Melwood training ground, where Liverpool Football Club trained for over sixty years until 2020, is ¼ mile (400 metres) up this road. It was transformed in the 1960s by Liverpool manager Bill Shankly who lived nearby, his house overlooking rival Everton's Bellefield training ground! Continue along Town Row to West Derby Village, passing the former village hall on the right and

the war memorial. Opposite, the Sefton Arms has an attractive hanging pub sign, depicting Croxteth Hall. At the side of the road is the stone drinking fountain and lamp (1894) with the words 'Water is best' on the rim, possibly as a rub to the pub just beyond it.

9 Turn right towards the entrance to Croxteth Hall Country Park ★. As you walk past the lodge house, spot the large 'S' (for Lord Sefton) in the stonework. Pass St Mary's Church (1856) then follow the drive for 1½ miles (2.5 km), passing under a bridge and the car park on the left, to which you will return. Croxteth Hall (construction started 1575) and its surrounding parkland were bequeathed to the people of Liverpool by the 7th Earl of Sefton, who died in 1972 without an heir. They are managed by Liverpool City Council and the estate also hosts an agricultural college.

10 Turn left and walk clockwise round the hall. On the west side you will see the low greenhouse and former kitchen garden. Walk through the Peach House to enjoy the walled grounds beyond. The late Lord Sefton encouraged flower-growing and wore a carnation in his buttonhole daily. Continue around the outside of the hall. At the front on the eastern side is a signpost to Croxteth Park Farm – follow your nose (!) to see some rare breed farm animals and a stable block. Once you have completed your circuit of the hall, take the path back to the car park, where the walk ends.

A̅Z̲ walk seventeen

Woolton

The sandstone village where John Lennon lived.

Woolton was listed as a settlement of eight families in the Domesday Book of 1086 and is older than the borough of Liverpool. By 1811, the population of the village was still only 671, whereas today it is about 13,000. The pretty sandstone village has now been engulfed by Liverpool's suburban development, but although most visitors come here to see where John Lennon grew up, there area has retained many other interesting features and hidden gems which we will see on this circular walk.

There are buildings dating back to the 1600s, parks with walled gardens and even the quarry that provided the red sandstone for the world's fifth-largest cathedral. We will pass Georgian buildings with windows bricked up to avoid paying the curious window tax and enjoy the charms of an original Victorian village centre including stone cottages, teashops, old pubs, churches and hidden cobbled alleyways.

Walking in the footsteps of the Beatles we will see John Lennon's childhood home, Strawberry Field and St Peter's Church Hall, where John met Paul McCartney while playing with his Quarrymen from the village. In the churchyard is the Eleanor Rigby headstone from the song, and the grave of Liverpool Football Club manager Bob Paisley.

There is a regular bus service from the city centre, and parking close to the start.

start / finish	Allerton Road bus stop, Woolton Street, Woolton
nearest postcode	L25 5JA
distance	5 miles / 8 km
time	2 hours 30 minutes
terrain	Paved roads and walkways. Cobbled paths and steps. Some inclines.

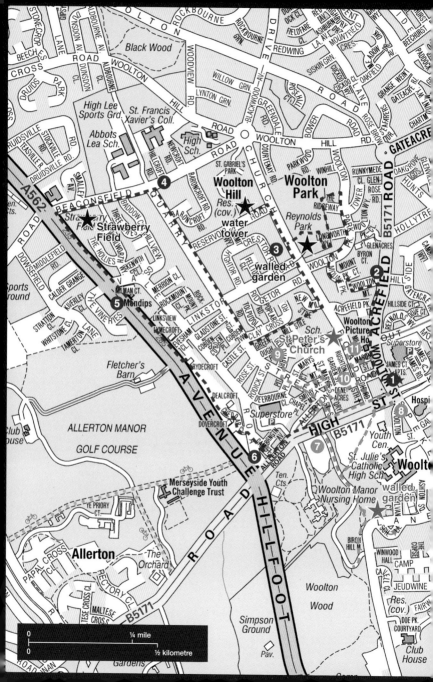

1 At the start of your walk, the car park behind you is the former duck pond. Across the road is The Coffee House pub (1641), one of the oldest remaining buildings in the village. To the left is a wrought iron streetlamp with cats and the initials 'RL' at the base (after Robert Leicester, the first rector at St Peter's Church). Turn left, away from the lamp, and walk along Woolton Street, which becomes Acrefield Road as you pass the White Horse Inn.

2 Turn left between the gateposts into Woolton Mount. Walk through to Mount Park Court, turning left and then right at the end onto Woolton Park. Continue until you reach the historical Reynolds Park. Enter Reynolds Park and follow the path round to the left and across the field until you find a gate into the walled garden ★. As you leave the walled garden, keep the large monkey puzzle tree on your right, and exit the park.

3 Turn right onto Church Road. On the corner of Reservoir Road there are two ancient stones marking the boundary of Much Woolton and Little Woolton (now known as Gateacre). A short way up the road, the water tower (1911) ★ is the highest point in Liverpool. Go back down Church Road and turn right into New Mill Stile. Follow a clearly marked footpath over the old quarry until you reach Quarry Street. Turn right onto Quarry Street. After nearly half a mile (700 metres), turn left at the T-junction onto Beaconsfield Road.

4 On the left you will find the famous gates to the Strawberry Field Visitor Centre ★, a former Salvation Army children's home. The Beatles song 'Strawberry Fields Forever' was released in 1967. At the traffic lights, turn left onto Menlove Avenue.

5 Just past some low green railings is John Lennon's childhood home. 'Mendips' is a 1930s black-and-white house with a blue English Heritage plaque on the wall. John lived here with his Aunt Mimi and Uncle George from the age of 5 and his bedroom was the small room above the vestibule. Continue along Menlove Avenue, joining a grass track by the tower block and then passing a glass art installation called *Outhouse*, installed in 2005. As the grass track ends, walk over the car park along Cheddar Close and cross Vale Road into Cam Street.

6 Turn left into an alley at the rear of Berrington Avenue. In Liverpool, alleys are known as 'jiggers', and metal coal chutes in the alley's brick walls were used to deliver coal directly into an outbuilding which was also the outdoor lavatory, 'the lav' or 'privy'. Continue along Cam Street then turn left to no. 120a Allerton Road, a dairy cottage once owned by John Lennon's Uncle George's family. Pass the former Woolton District Nursing Home (1904) onto High Street. At the former United Reformed Church (1865), now a care home, cross the dual carriageway to your right and enter Woolton Woods through the gates.

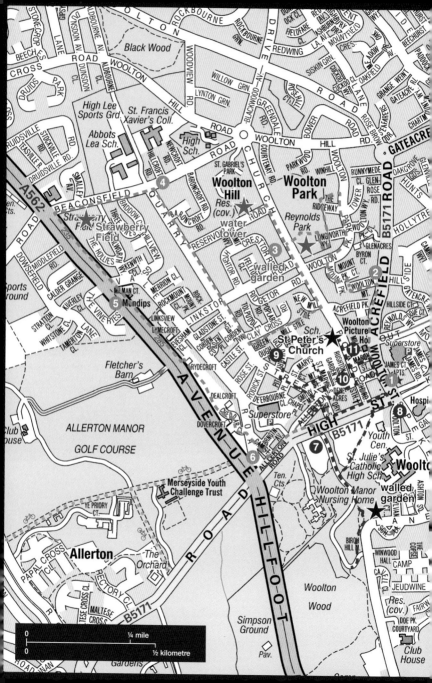

7 Follow the marked path to the walled gardens ★ of Woolton Woods. Leave the gardens using the same gate, taking the left-hand path towards a few wooden benches with views over the River Mersey to the mountains of North Wales. Return past the walled gardens, taking the path diagonally right across the field to High Street and turning right to the junction with Kings Drive and Woolton Street. On your right is the 15th-century Town Cross.

8 Cross the dual carriageway towards the village, turn left and walk along High Street. Turn right onto Quarry Street South. On your right is a Georgian house with the middle window boarded up to avoid window taxes collected from 1697 to 1851. On the corner is the former Victorian swimming baths, with terracotta faces on the walls. Turn left onto Allerton Road. On your right is a blue plaque on the former Woolton Library (1834). Turn back and then left at the Grapes pub onto Quarry Street until you reach Old Quarry, which provided most of the sandstone used to build Liverpool Cathedral.

9 Return onto Quarry Street towards the village. Turn left onto Mount Street and left again into St Mary's Street, where there is a blue plaque on the former Mechanics Institute (1848). Walk up the steps to see St Mary's Catholic Church (1860). Return along St Mary Street, turning left onto Allerton Road until you reach an old drinking fountain with the same 'RL' initials that we saw

earlier on the streetlamp. Turn left and walk up Church Road to The Simon Peter Centre, St Peter's Church Hall. Above the door is a plaque explaining that Paul McCartney was introduced to John Lennon here on 6 July 1957.

10 Continue up the hill and enter St Peter's Church (1826) ★ through the lychgate and turn immediately left, passing a war grave. Opposite the war grave are headstones marked Rigby and McKenzie. Behind these you will find the Eleanor Rigby grave. 'Eleanor Rigby' is a Beatles song written by John Lennon, who sang in the church choir. Father McKenzie is mentioned in the lyrics. Return to the lychgate and turn left, passing some wooden benches and the memorial garden. Just after the path turns right, is the headstone of Bob Paisley, the Liverpool Football Club manager from 1974 to 1983.

11 Return down Church Road and turn left onto Mason Street to Woolton Picture House (1926), the oldest single-screen cinema in England. Turn right onto Woolton Street to complete your walk.

▲Z walk eighteen

Over the Water

Woodside and Hamilton Square.

Imagine the days when you might have taken a tram to the ferry terminal to cross the River Mersey to Liverpool, or perhaps you might have sailed away on a boat built by one of England's largest shipbuilders. This is a true walk of maritime history, passing Woodside Ferry Terminal, with its Grade II listed booking hall, and taking in views over the docks of the Cammell Laird shipyard. Along the way we will see some of the earliest buildings in the county of what was then Cheshire. Wirral, the peninsular across the river from Liverpool, became part of Merseyside in 1974 and is now a separate metropolitan borough.

This circular walk is centred on the town of Birkenhead, one of the peninsula's main towns. Earning the town its place in transport history, it was the medieval monks of Birkenhead Priory that provided the original Mersey ferry and it was here that the first horse-drawn trams in the world were introduced (ironically designed by George Francis Train). The town also boasts one of the finest Regency-style squares in England.

Regular trains from Liverpool stations (Central, James Street and Moorfields) make the short journey to Hamilton Square Station. You also have the option to travel via ferry from the Pier Head to Woodside Ferry Terminal, a short walk away from the station (check first that the ferry stops at Woodside).

start / finish	Hamilton Square Railway Station, Birkenhead
nearest postcode	CH41 1AL
distance	2¾ miles / 4.4 km
time	2 hours
terrain	Paved roads and walkways. Steps (optional).

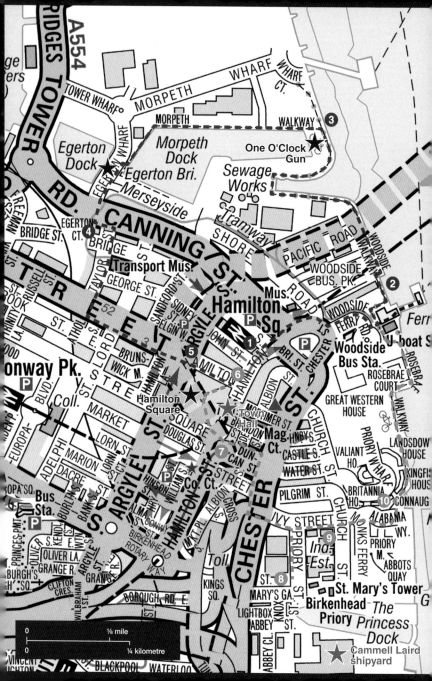

1 Turn left out of the station and carry on through the road junction. Turn left, following signs for Woodside Mersey Ferries. When you reach the terminal, walk to the left of the building to the riverside. (If arriving on the ferry, leave Woodside Ferry Terminal passing German U-boat U-534 on your left and turn right around the side of the building to the promenade). You are immediately greeted with the most amazing waterfront views of Liverpool.

2 Follow the riverside walkway, keeping the river to your right and walking towards a tall Art Deco-style tower. Designed by Herbert J. Rowse, this is a ventilation shaft for the 1934 road tunnel connecting Birkenhead and Liverpool. On your right is a ferry terminal providing a daily 'roll-on-roll-off' (RoRo) service to Belfast in Northern Ireland. Follow the Morpeth Walkway to the One O'Clock Gun ★ (this cannon is a smaller replacement of the original). The gun was connected electrically to the nearby Bidston Observatory and fired at exactly 13:00 Greenwich Mean Time to allow the ships to set their chronometers.

3 Shortly after the cannon, turn inland to walk with the dock on your left-hand side then turn left to cross a bascule bridge ★ (*bascule* is the French word for seesaw). As you cross the bridge you will have Morpeth Dock on your left and Egerton Dock on your right. Both docks opened in 1847. Continue to the end of Egerton Wharf.

4 Turn left onto Canning Street, crossing the tram lines, then turn right onto Taylor Street, to the entrance of the Transport Museum. Usually open at weekends and during the summer school holidays, entrance to this hidden gem is free of charge and you can experience a heritage tram ride towards Woodside Ferry Terminal. Birkenhead had the first passenger trams in the world, designed by George Francis Train. Continue along Taylor Street and turn left onto Cleveland Street, which leads you to Hamilton Square ★ .

5 This square has the most Grade I listed buildings anywhere outside of London, and was designed in 1825 by James Gillespie Graham, who designed much of Edinburgh and Glasgow city centres. The land was owned by William Laird, a shipbuilder who named the square with his mother-in-law's maiden name. Keep to the left side of the small park, with the iron railings to your right. The houses, starting at 18 Hamilton Square, have the features typical of a late-Georgian house: six-panel half-hung sash windows, a raised basement, steps to the front door with a wrought iron boot scraper at the bottom. Also note the portico entrances and railings around the basements.

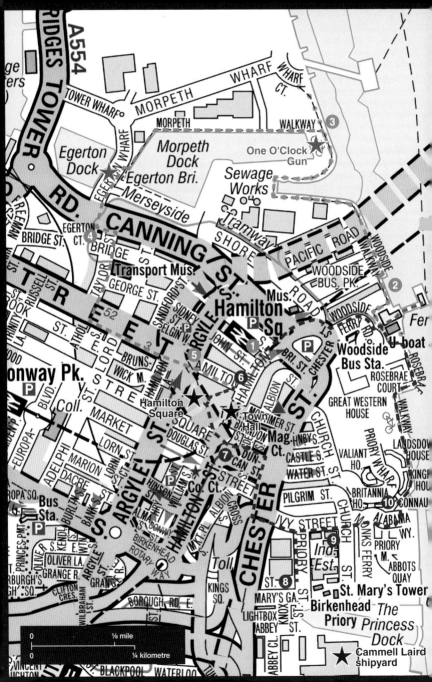

6 Facing you at the corner is no. 63, where John Laird, one of William Laird's three sons, lived. He continued his father's shipbuilding and repair business, which was later to become Cammell Laird. You cannot miss the 200-foot (61-metre) clock tower of Birkenhead Town Hall ★. This building opened in 1887 as the town's civic hall, a music hall and assembly rooms with the magistrate's court at the rear. In the centre of Hamilton Square, the gardens were once a private park but are now open and home to Birkenhead's war memorial, designed by Herbert Tyson-Smith and unveiled in 1925. You will also find a statue of John Laird and a memorial to a local police officer. In the centre is a memorial to Queen Victoria.

7 Turn along the left-hand side of the Town Hall along Duncan Street then turn right onto Chester Street. Continue for about 400 yards (365 metres) then cross over Chester Street to walk up Ivy Street. Turn right onto Priory Street to Birkenhead Priory. The oldest parts of the medieval building date back to 1150 and it was visited by King Edward I ('Edward Longshanks' or 'the Hammer of the Scots'). The monks were given the rights to operate a ferry across the River Mersey in the 13th century.

8 Within the priory grounds is St Mary's Church, which opened in 1821. The climb to the top of the church tower (check opening times) is perhaps the highlight of this walk. See the mechanism of the church clock halfway up the steps, before emerging at the top to see panoramic views across the river and into the dry docks of Cammell Laird's shipyard ★. Leave the Priory and retrace your steps back along Priory Street, turning right onto Ivy Street.

9 At the junction of Ivy Street and Church Street, to your left you will see a sandstone wall on one side of what was once a bridge bringing a railway over Monks Ferry. Continue downhill on Monks Ferry, turning left into Alabama Way. In 1861, James Dunwoody Bulloch arrived in Liverpool as an agent for the Confederate States of America. He was to control much of the sale of cotton through the Confederacy and approached Laird and Sons to build an iron-clad wooden ship. The CSS *Alabama* was launched in 1862 from Laird's shipyard.

10 At the riverside, turn left and walk back to Woodside Ferry Terminal. To return to the railway station, walk away from the front of the terminal building, keeping right as you join the road, and head for the tall red brick tower of the station.

⒜⒵ walk nineteen

'Little Gibraltar of the Mersey'

New Brighton and Fort Perch Rock.

On the corner of the Wirral Peninsula at the mouth of the River Mersey, a Liverpool merchant named James Atherton purchased land on which to develop a fashionable resort in the 1830s. With sea bathing increasing in popularity and regular steam ferries to Liverpool, the settlement of New Brighton flourished. On this circular walk, you will sense the purpose of this planned oasis as you pass along the promenade and through Victorian parks with bandstands. You will see a giant castellated Edwardian water tower and a conservation area where gunpowder was stored.

Fort Perch Rock was constructed in the 1820s to defend the Port of Liverpool. This fascinating Georgian relic was put to military use during the Second World War, armed with eighteen guns and earning the nickname 'Little Gibraltar of the Mersey'. Enjoy the panoramic views across the Mersey and along the waterfront to the Port of Liverpool, with its gigantic red cranes reaching the same height as the birds atop Liverpool's Royal Liver Building.

New Brighton has enjoyed a recent revival, with street art, cafés, ice cream parlours and families bathing on beaches patrolled by lifeguards. The constant reconstruction of the Black Pearl, a pirate ship made from driftwood, is a reminder to 'keep your eyes peeled and your powder dry'.

There is a regular train service between Liverpool stations (Central, James Street and Moorfields) and New Brighton.

start / finish	New Brighton Railway Station
nearest postcode	CH45 0JZ
distance	4¼ miles / 7 km
time	2 hours
terrain	Paved roads, walkways and paths. Short, steep cobbled lanes.

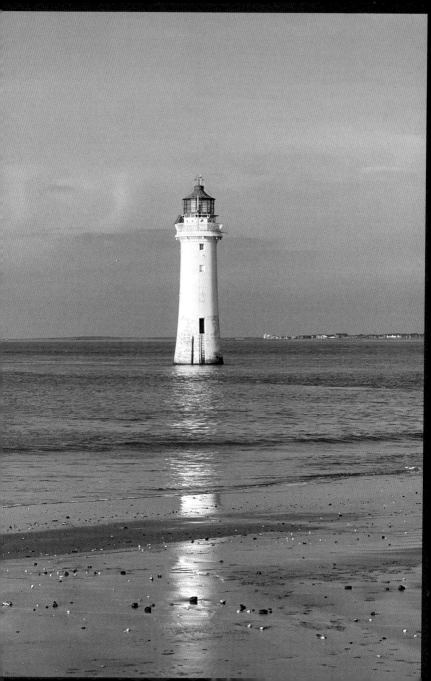

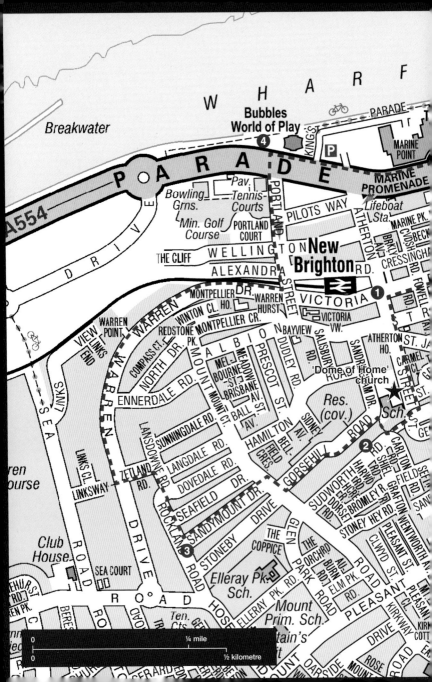

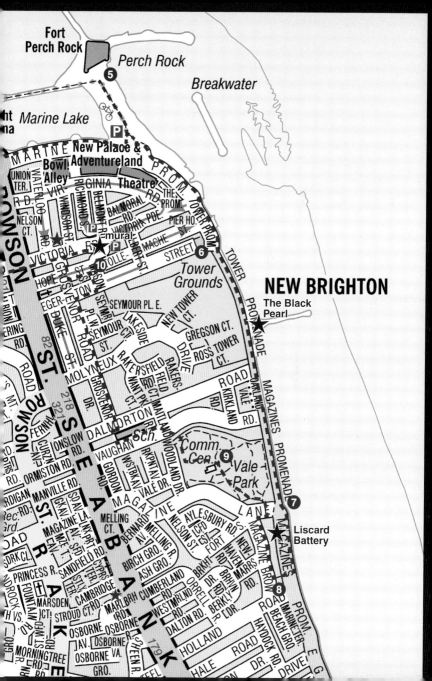

Fort Perch Rock

Perch Rock

⑤

Breakwater

Marine Lake

ht na

Ⓟ

🚲

MARINE

New Palace & Adventureland

Bowl Alley

Theatre

UNION TER.

WATERLOO RD.

VIRGINIA

RICHMOND RD.

WINDSOR

BELMONT RD.

BALMORAL RD.

VICTORIA PDE.

NELSON CT.

Ⓟ

mural

PROM.

THE PROM.

PIER HO.

TOWER PROM.

VICTORIA

OLLE.

MACHE.

STREET

⑥

HOPE ST.

GROSVENOR

⑩

GROSVENOR ST.

EGER-

DUKE ST.

SEYMOUR PL. E.

Tower Grounds

NEW BRIGHTON

The Black Pearl

ROWSON

82 ST.

SEYMOUR

PL.W

SEYMOUR ST.

LAKESIDE

NEW TOWER CT.

GREGSON CT.

ROSS TOWER CT.

ROWSON

ROAD

FERNH

CURZN

218

321

MOLYNEUX

GROSVENOR DR.

BAKERSFIELD

NANT.PK.

BAKERS CT.

MAITLAND

DRIVE

ROAD

KIRKLAND RD.

GARLAND

VALE RD.

MAGAZINES

PROMENADE

ONSLOW

DALMORTON

Sch.

WOODLAND DR.

RKPNTAIL

ORMISTON RD.

VAUGHAN

GORDON

WSTBKN.

VALE DR.

Comm. Cen.

⑨

Vale Park

CARDIGAN RD.

Rec. RD.

DRKCL.

MANVILLE RD.

MAGAZINE LA.

SD.AV.

GKAN. LA.

NP.T.

MELLING CT.

MAGAZINE

BERNARD AV.

MELLING R.

AYLESBURY RD.

NELSON ST.

ICFD EST.

FORT

LANE

⑦

✦ **Liscard Battery**

PRINCESS R.

FOUNTAIN

SANDFIELD RD.

CYPRS. TER.

BIRCH GRO.

ASH GRO.

CUMBERLAND RD.

ORRELL RD.

WESTMRLND. RD.

DALTON RD.

BRKHT

HAVENS

MARRS RD.

BERKLY RD.

BRWIN

P. LDR.

NEW

MARINER

BEACH GRO.

PROM.

ROAD

⑧

MARSDEN

CAMBRIDGE

STROUD CT.

MARLBRH RD.

H VS.

MORNINGTREE

OSBORNE

OSBORNE AV.

OSBORNE VA.

GRO.

SHEEN R.

STEEL

179K

HOLLAND ROAD

HALE ROAD

HAYDOCK RD.

DRIVE

E G.

1 Leave the station, walking up the hill along Atherton Street (after James Atherton, who created New Brighton). You will soon arrive at an imposing baroque-style Catholic Church, a Shrine Church dedicated to Saints Peter, Paul and Philomena (1935). With its dome visible from the river, it became a welcoming landmark and was known as the 'Dome of Home'. Walk around the back of the church into Gorsehill Road.

2 On your right, Gorse Millennium Green is the highest point in New Brighton. This small park was saved by locals from property developers to create a peaceful retreat. The solid red sandstone water tower is 82 feet (25 metres) high and opened in 1905. It holds 70,000 gallons of Welsh drinking water, supplied by a 68-mile (110-km) pipeline from Lake Vyrnwy. Continue along Gorsehill Road, turn right into Mount Road then immediately left onto Sandymount Drive and walk to the end.

3 Turn right onto Rockland Road and follow it round to the end, turning left on Lansdowne Road. Take the next left onto Zetland Road and at the end, turn right onto Warren Drive. This road boasts some of the town's most splendid residences, with views to Cheshire and North Wales. Continue around the curve of Warren Drive for half a mile (800 metres) then turn left onto Portland Street, which slopes down to the coast.

4 Turn right onto King's Parade and continue for a further half mile (800 metres), going straight on at the roundabout and walking along Marine Promenade with Marine Lake on your left. Turn left at the Floral Pavilion theatre to Fort Perch Rock. This fortress was built in 1829 to defend the River Mersey and accommodate a garrison of over a hundred men. Open to the public, it houses a museum of military aviation and maritime history.

5 From Perch Rock you can see the lighthouse standing 94 feet (28.5 metres) high and known as the Black Rock or Perch Rock Lighthouse. The original lighthouse used an audible warning or 'perch' to warn ships of the dangers of running aground. It was replaced by the current lighthouse in 1830, which operated until 1973. Turn back towards the Floral Pavilion and continue left along Marine Promenade to where the road turns away from the coast at the Tower Grounds.

6 This was the site of the 567-foot (173-metre) steel New Brighton Tower, which was modelled on Paris's Eiffel Tower. It was dismantled in 1919 though the ballroom beneath it remained, until destroyed by fire in 1969. Continue along the pedestrian riverside promenade, which was constructed in 1879. Look out for a quirky driftwood pirate ship called the Black Pearl ★ to the left, then continue until you reach Dr Poggi's Shelter, with its decorative wrought iron columns

and rare Minton tiles. A blue plaque commemorates Italian-born Dr Poggi, who ran the New Brighton College where the sons of the Italian liberator, Garibaldi, were educated.

7 Continue past Magazine Lane to the war memorial in front of the Liscard Battery ★. The battery was constructed in 1858 for a small garrison, the 55th Royal Artillery, and became redundant in 1912. Continue along the promenade for a further 150 yards (140 metres) and turn right up the short, cobbled slope of Pengwern Terrace. At the top, turn right onto Magazine Brow. The Magazine Hotel (1759) to your left was built in what was once a small fishing village, now a conservation area. The 'magazines' were underground chambers built in the mid-eighteenth century to store gunpowder for ships in the Port of Liverpool.

8 Continue along Magazine Brow, passing The Pilot Boat pub, built in 1747. The row of white cottages next to it has a set of mounting steps built into the wall at the end. Where the road meets Magazine Lane, turn right past the 19th-century entrance to the gunpowder magazine. Just before Dr Poggi's Shelter, turn left to enter Vale Park. Follow the signs for the café and bandstand. The bandstand was built in 1926 with a domed roof supported on Doric columns. Around its base are the names of classical composers inscribed in gold lettering.

9 Take the path behind the café, passing ornamental gardens on your right and a children's playground, then turn left behind the houses and leave the park, turning left onto Vaughan Road. Take the passageway on the right just after the school and continue ahead on Grosvenor Drive, which becomes Grosvenor Road after Molyneux Drive. Turn right at Egerton Street. Turning left into Mason Street, you will see a series of murals. With more than fifteen artworks painted by local and international street artists, the Mason Street mural reflects the Backbeat era of the 1960s, associated with the Tower Ballroom on the promenade.

10 From Mason Street, turn left onto Hope Street. On the corner are two further murals, one a cleverly painted green tram, the other, a picture of the driftwood pirate ship the Black Pearl. Turning right onto Grosvenor Road, spot The Harbour pub mural then turn right to find more street art along Victoria Road as you make your way to the Mason Street roundabout to see the Black Rock Mermaid mural ★ next to the former tram terminal. In 1860 the nearby town of Birkenhead had the world's first passenger tramway and the local trams terminated here until 1937. Turn back along Victoria Road to return to the railway station, the end of your promenade.

AZ **walk twenty**

A Garden Village

Port Sunlight Conservation Area.

The beautiful garden village of Port Sunlight in Wirral was planned to the last detail by soap magnate and architectural enthusiast William Hesketh Lever (1851–1925). The son of a Bolton grocer, he started selling soap and after huge success, began looking for a suitable site to expand his Lever Brothers business. Having acquired, then drained, a large plot of land alongside the River Mersey, he enlisted more than thirty architects to create a village for his workers. This was constructed between 1889 and 1914, and most of the more than 900 buildings are now Grade II listed. Palm oil was shipped to the purpose-built port and then processed into soap at the nearby factory, both conveniently located close to the workers' housing.

This circular walk through the picturesque industrial village, named after Lever Brothers' most successful product, 'Sunlight Soap', takes us past the factory, the workers' cottages and the community facilities that Lever provided for his employees. A visit to Lady Lever Art Gallery, dedicated to his wife Elizabeth Hulme, is highly recommended (check opening times) to see the art, furniture and pottery that Lever's success enabled him to collect, and also to learn about the source of his wealth and the working conditions of the people of the Belgian Congo, from where the soap's raw material was obtained.

There is a regular train service from Liverpool Lime Street Station to Port Sunlight.

start / finish	Port Sunlight Railway Station, Greendale Road, Wirral
nearest postcode	CH62 4XB
distance	2 miles / 3 km
time	1 hour (excluding gallery and museum visits)
terrain	Pavements and paved walkways, steps.

1 As you leave the station, opposite and slightly to the left is the former Post Office, which is now a lovely tearoom. Turn right on Greendale Road and pass the black and white timber Tudor Revival building, once the workers' bank, and then a bowling green. The Gladstone Theatre, on your right, is the oldest building in the village (1891) and was formerly the men's dining hall. Facing you is the distinctive clock on Lever House (about 1888), which was Lever Brothers' head office and soap works.

2 Follow Greendale Road round to the left as it becomes Wood Street. Take the first left, behind the old bank, to see the former fire station for the factory. Return to Wood Street and continue along, pausing at no. 17 and looking to your right across the road towards the factory. A gap in the buildings shows at least half a mile (800 metres) of manufacturing plant. Turn left at Bridge Street and cross over the picture-postcard Dell Bridge ★ . The Dell is a drained and landscaped tidal creek of the River Mersey, a reminder of the marshland on which the village is built. The Lyceum Club (1896) and clock tower were once the village school and a place of worship before the church was built.

3 At the end of Bridge Street, cross over Bolton Road and turn right. Hulme Hall (1901) ★ was built as the ladies' dining hall and later became an art gallery. A small plaque on the building denotes Ringo Starr's first gig with the Beatles. Continue along Bolton Road and turn left just before The Bridge Inn (1900). When it opened, it did not serve alcohol but such were the complaints that William Lever put it to a vote, which he lost!

4 Walk along Church Road to Christ Church (1904). There is a lychgate to this substantial Gothic Revival church, which seats 800 people. At the north end of the church is a vaulted porch enclosing the tomb of William Lever and his wife Elizabeth Hulme. In the churchyard there are eight graves of First and Second World War soldiers. Opposite the church is a wide double street called The Causeway. Walk along to the impressive war memorial (1921), designed by renowned sculptor Goscombe John. The names of the factory workers lost in both World Wars are inscribed. The memorial has an unusual theme, 'The Defence of the Realm'; and as Lever wanted to portray a sense of community, the design includes women and children as well as soldiers.

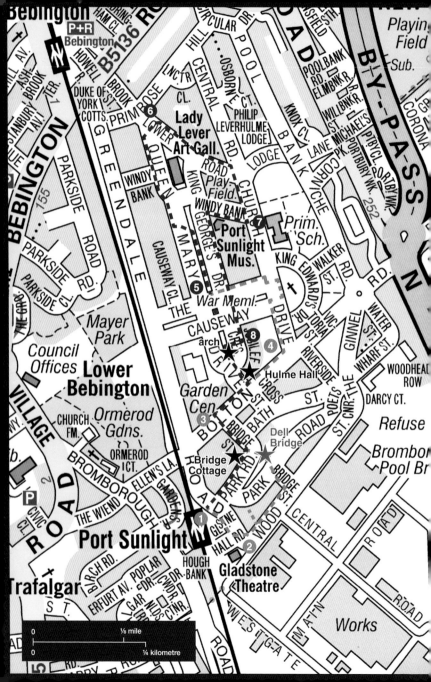

5 From the war memorial, turn right and walk along the central grassed walkway and rose garden, passing the analemmatic sundial and fountain. Lady Lever Art Gallery (1922) was purpose-built for Lever's art, antiquity, furniture, tapestry, sculpture and Wedgwood pottery collections. The gallery includes paintings by Turner, Constable and Reynolds, and has one of the largest collections of pre-Raphaelite art in the country. It is well worth a visit. To the left-hand side of the gallery, you will see a modern black obelisk, the Leverhulme Memorial. Behind, a wonderful house on the right has a blue and white simple oriel window, emulating Lever's appreciation for Wedgwood Jasperware pottery.

6 Continue walking clockwise around the art gallery until you see a crescent-shaped terrace with iron verandas and tiny rooms in the roof. These beautiful Arts and Craft-style houses built in 1905 are unique within the village, yet typical of the architect Charles Reilly, who was head of the Liverpool School of Architecture. Continue along Lower Road and cross over at the junction between Central Road and Church Drive. On your left you can see the roof of the former Port Sunlight Cottage Hospital, which was open to Lever employees for free treatment until the start of the National Health Service. Turn right at this junction onto Church Drive and continue to the school, which is now the main school of the village.

7 Opposite the school is a large corner house with the unmissable date of 1900 on the white semi-circular roof apex. Keep this house on your left and turn into Windy Bank, past the red brick turreted cottage of the same name (1907). On the next corner is the Port Sunlight Museum, once a girls' club specializing in crafts and dancing, also worth a visit. Turn left along King George's Drive, passing the war memorial into Jubilee Crescent. From this point you can see the Garden Centre, once the village gymnasium and open-air circular swimming pool, heated from the factory.

8 You will soon reach the arched entrance arch of the ornamental gardens over to your right. These gardens were re-dedicated as the Hillsborough Memorial Gardens after ninety-seven Liverpool Football Club fans died in 1989. From the arch of the memorial gardens, continue along the side of Hulme Hall and turn right onto Bolton Road. Pass the two bowling greens and turn left onto Bridge Street. Bridge Cottage (1897) ★, on the bend, was the once the home of the Lever family. The road becomes Park Road after the bend. The houses along here are also quite imposing, with film credits including the popular TV series *Peaky Blinders*. Continue towards the station, past the red phone and pillar boxes, where the walk ends.

images